ZONE VI
WORKSHOP

The *Fine Print*
In Black & White Photography

FRED PICKER

AMPHOTO
American Photographic Book Publishing Co., Inc.
Garden City, N.Y. 11530

ACKNOWLEDGMENT
*I am most appreciative of the contribution
of Lillian Farber who helped to organize the
material, clarify the text, and correct the proofs.*

Published in Garden City, New York,
by American Photographic Book
Publishing Company, Inc.

Manufactured in the United States
of America.

Library of Congress Catalog Card
No. 73-93529

ISBN 0-8174-0574-7

Third Printing September 1975

TABLE OF CONTENTS

Author's Note

The technical and mechanical aspects of making a photograph begin a sequence with the setting of camera controls and ending with the display of the finished print. Each step depends on and often modifies the results of the previous step. For this reason, it is important that this Workbook be read in sequential order. Those with an urge to skip about or read only specific sections will be confused.

The reader may have questions that seem to go unanswered. My teaching experience indicates that it is often best not to digress from the subject at hand, but to pick up the loose ends after the whole is explained. Reading through each section will clear up most difficulties.

There are repetitions. They are intentional and related to the importance of the concept.

There are three tests described in this workbook that will synthesize the photographer's equipment and procedures for optimum and predictable results. These three tests are:
1. Personal Film Speed Test,
2. Normal Development Time Test,
3. Exposure of Proper Proof.

They are the basis of all the material presented in this workbook. Once done, they become your personal standard for all future work unless you change any of the equipment you work with, such as film, developer, camera, enlarger, etc.

The tests are meaningless unless each is carried out in order. The tendency of some students is to devise a short cut which invariably results in an inconsistency. If you follow the procedures, all the tests can be completed in 3-5 hours.

I am aware that many of the statements in this book are contradictory to accepted doctrine and may be challenged by others. Nevertheless, exhaustive tests have demonstrated that anyone can achieve the results described if the step by step instructions are carefully carried out.

Due to the reproduction process, loss of quality in the illustrations is inevitable. In some cases, descriptions of the photographs will be more accurate than the reproductions.

INTRODUCTION

The Zone VI Workshop has been in existence for several years and during that time I have learned much from the students. I am convinced that the majority of people who photograph never reach the level of artistic expression of which they are capable.

The emotion and intellect present at the time of exposure is often so weakened by haphazard technique that the final presentation—the print—does not communicate the intensity felt by the photographer for his subject.

Technique is not an end in itself; too often it is a stumbling block that bars the path to an esthetic statement. When technique is mastered and controlled it enhances the creative process.

I teach technique. Each student has his own creative potential. They have taught me that the greatest contribution that I can make to their growth is to free them from the unsatisfactory results of slipshod procedures so that they can go about the real business of photography with confidence in the beauty and power of the final outcome.

Their renewed joy in photography justifies the time spent in following the procedures described in this work book.

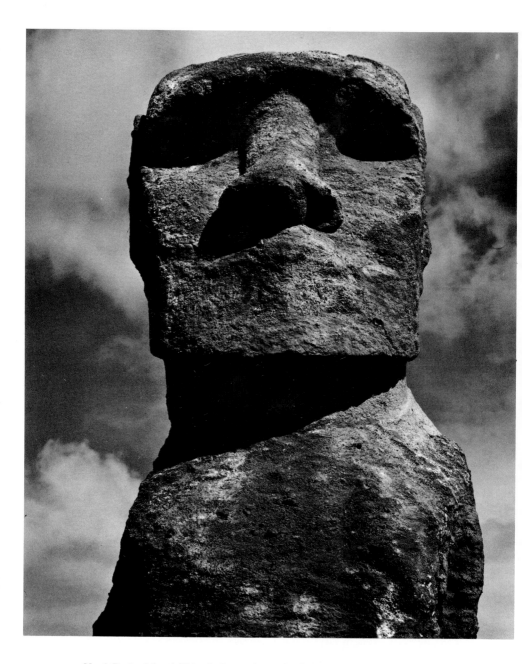

Moai, Easter Island: This photograph required view camera movements and a long lens. The figure was four stories tall and an up pointing camera would have caused convergence of verticals creating a "pinhead" effect. By backing away, the vertical angle was reduced and the camera was leveled. Without movements, the field would have included the ground and the figure up to its waist so the lens was raised to frame the head. Sinar 4x5, 12 inch Goerz Artar. This photograph was chosen for the dust jacket of the book, "Rapa Nui."

EXPOSURE

Almost all students think that their major technical problem is printing. They are not aware that in almost every case their negatives are just not good enough to produce fine prints. Improper negative exposure and development has been the basic problem.

In the fraction of a second of an exposure, an entire chain of events begins. The precision of this first step is of major importance if a fine print is to result.

The exact camera setting necessary to achieve predetermined tones of gray in the print is never a problem if the following basic characteristic of exposure meters is thoroughly understood:

A reflected light exposure meter reading of any evenly illuminated single toned surface provides camera setting information that will result in a negative density which will produce a "middle gray" in the print. *

This middle gray in the print always results regardless of the tone, color or character of the subject matter or the intensity of the light it receives or reflects.**

An exposure meter is a measuring device and like a thermometer that impartially indicates the temperature of hot gravy or ice water, the meter impartially indicates the intensity of the light that is striking its cell. No meter can tell dark barnwood from a white card. It can only measure the light they reflect, and when the dial is manipulated or the pointer centered, etc., the exposure indicated by a reading of the card or barnwood will result in "middle gray" in the print. (See illustration.) Every meter, every subject, every time—middle gray.

*Based on the assumption that the negative is given the minimum exposure in the enlarger that will produce maximum black through its unexposed edge. More about this later.

**Exceptions to this rule occur in those cases where exposure times are longer than one second or shorter than 1/1000 of a second. This is called Reciprocity Departure and must be compensated for by giving more exposure than the meter indicates.

White card in sun; the indi- Dark barnwood in shade; the
cated exposure of 1/1,000 at indicated exposure of 1/30 at
f/16 produces middle gray. f/5.6 produces middle gray.

The meter has measured differing intensities, but has indicated settings that will allow the same amount of light to reach the film. In both instances, the subject appeared middle gray in the print. In neither instance was the result esthetically acceptable.

Average Readings of Reflected Light Meters

"Average meter readings are exceptionally dangerous, merely because they are weighted according to the areas occupied in the subject by different luminances. To take a trivial example, a black-and-white checkerboard requires the same negative exposure as one all black except for a single white square. Yet an average meter reading would be quite different for the two subjects."*

*Hollis N. Todd and Richard D. Zakia. Photographic Sensitometry, The Study of Tone Reproduction. Hastings-on-Hudson, New York, Morgan and Morgan, Inc., 1969, p. 78.

Experience has shown almost everyone that average readings seldom indicate an exposure compatible with the photographer's visualization. To solve the problem, many photographers, including an embarrassing number of professionals, "bracket" their exposures. Some photographic writers advocate it; film manufacturers love it; but how do you bracket a fleeting expression or a touchdown pass?

Often the desired exposure is more than three stops from the average reading and no bracket would cover it. (See Lake illustration).

In addition, slipshod methods such as bracketing are destructive to the creative process. No one can create freely when doubts concerning desired results plague him. The strength of anyone's photographs, the seeing, the arranging, the approach to the subject, improve dramatically as the technical problems are solved.

Manufacturers of exposure meters, both hand-held and in cameras, must adjust their meters for "average" scenes. There is really nothing else they can do. A reading through the lens of the meter in the camera or a reading of the area to be photographed with a hand meter might give you a "realistic" exposure if the scene covered by the meter's field contained a group of objects that together average middle gray (18% reflectance). Many manufacturers calibrate their meters for 18% reflectance. Others calibrate for 36%. 36% meters indicate one stop more exposure than the 18% meters. Manufacturers can't agree on what is "average" simply because "average" varies depending on the percentage of high and low values in the scene.

Some cameras have center-weighted meters. The designers of these cameras assume that you want the center of all your compositions to be middle gray. (See Lake illustration).

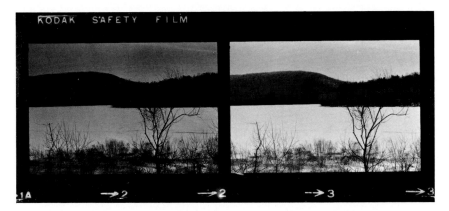

Snow covered lake in blazing sun. Average reading with through the lens "center weighted" meter indicated an exposure of 1/1,000 at f/22. The lake appears as middle gray and all other values are similarly depressed. The picture completely fails to recreate the mood. The second picture was exposed at 1/1,000 at f/8 and the tones are recreated as visualized. A Weston ranger 9 Meter was used and manipulated in a way that will be described. The difference between the average exposure and the visualized result is three stops-eight times more exposure. If the film had been rated in accordance with manufacturers recommendation (ASA 400) instead of my tested rating for my equipment (ASA 200) the first picture would have been four stops from the desired exposure — sixteen times less exposure than was required.

Some meters do more than indicate settings—they act. In the same way that a voltage regulator installed between the wall outlet and an enlarger adjusts to the ebb and flow of the line voltage to deliver a constant flow of electricity, the electric eye camera meter adjusts the lens opening or the shutter speed to pass a metered amount of light to the film. The amount of light it allows to pass never varies and always results in—middle gray.

Ansel Adams learned years ago how to manipulate this middle gray reading characteristic of reflected light meters to achieve predetermined print values. He worked out a logical straightforward system that, with a Weston meter (modified with a Zone scale) can be taught to a beginning photographer in an hour. Teaching a photographer with more experience takes longer! He can't believe it will work. The beginner just rotates the dial placing the light value reading of the subject opposite the Zone (tone of gray) that he wants in the print. Then he exposes according to the meter's direction.

4

Ansel's book, "The Negative," is the definitive work on negative exposure and development. His method is called:

THE ZONE SYSTEM

Envision making an exposure meter reading of a black horse. The meter is close enough to the horse to insure that no other reflecting surface is in the meter's field of view. It is important that the meter be aimed along the lens axis and that it casts no shadow on the area being metered. An exposure is made using the speed and aperture settings indicated by the meter or centering the pointer, etc. Next an exposure meter reading of a white horse is made. The exposure is made using the speed and aperture settings indicated by the meter.

When the film has been processed a contact print of both negatives side by side (or an enlargement of equal duration and magnification of each negative) will result in matching photographs of "middle gray" horses. (See illustration.)

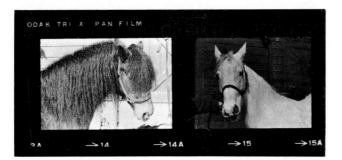

The black pony and white horse were photographed in the same location and in the same light. They both appear as middle gray. The pony appears slightly darker than the horse because of the overexposed background. Both exposures were made by using the exposure information supplied by the meter. Neither exposure is acceptable.

How then do you get the black horse black?

The exposure meter indicates camera settings that would result in middle gray (Zone V). Close down the lens aperture one stop and the horse has been placed one Zone darker (Zone IV). Zone IV is often used for the shaded side of a portrait in sun. Another stop down (or an increased shutter speed—1/50 shortened to 1/100) and the horse is still darker (Zone III). That seems about right for a black horse—to me. (See illustration.) Further reduction of exposure to Zone I would result in near solid black with no sign of texture (a silhouette).

These diminishing exposures result in less and less negative density. Each reduction of one stop reduces (darkens) the print value one Zone.

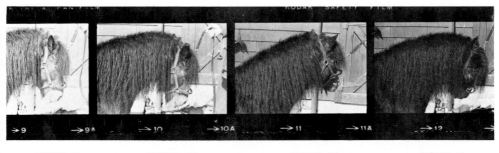

ZONE V	ZONE IV	ZONE III	ZONE II
(meter reading)	(1 stop less)	(2 stops less)	(3 stops less)

Back to the white horse.

The exposure meter indicates camera settings that would result in a middle gray (Zone V). Open up the aperture one stop and the horse has been placed one Zone lighter (Zone VI). Zone VI is often used for the sunny side of the face in a portrait in sun. Another stop up (or a decrease of shutter speed—1/100 lengthened to 1/50) and the horse is still lighter (Zone VII). That seems about right for a white horse—to me. (See illustration.)

Further increase of exposure to Zone VIII would result in near solid white (very little texture).

These increasing exposures resulting in more and more negative density each appear in the print one Zone higher (lighter) for each opening of one stop.*

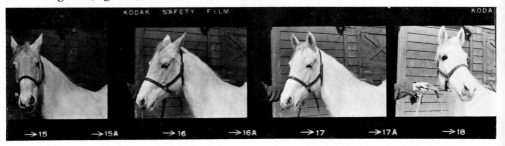

ZONE V	ZONE VI	ZONE VII	ZONE VIII
(meter reading)	(1 stop more)	(2 stops more)	(3 stops more)

The above placements of the black horse on Zone III and the white horse on Zone VII would result in a close approximation of "reality." Controlled departures from reality are available to the photographer with a controlled technique. Either horse could be placed on any Zone!

Any single value (black horse or white horse) can be placed on any Zone, but subjects of the real world—the subjects we photograph—are a conglomerate of light, shadow and tone. How then can we place them all? We can't.

We can place only one value and all other values then fall on their related zones in accordance with the amount of light they reflect.

*If you have trouble remembering which is opening up and which is closing down, think of f stops as fractions. f/22 (1/22) is smaller than f/11 (1/11), a smaller opening, less light. An f/2 lens at f/2 is wide open while at f/16 or f/22 it is closed to minimum aperture.

Visualize a head and shoulders portrait. The meter is adjusted to the ASA speed recommended by the film manufacturer (more about this later) and we take a reading of the subject's face being careful that no other area impinges on the meter's field of view*. The meter needle rests at the #12. (See illustration.) Rotating the zoned dial so that Zone VI is opposite the #12 places the flesh tone on Zone VI. (See illustration.) Without moving the dial the background is metered and the needle rests at the #13. A glance at the dial shows the background (13) falls opposite Zone VII. We now read the subject's black sweater and the needle moves to #7. The meter dial reveals that #7 falls opposite Zone I. Settings, (1/30 at f/4 or equivalent) are read from the opposite side of the meter dial and transferred to the camera controls. You can visualize the final print! This moment of revelation has been shared by many great photographers. Minor White recalls:

> "Ansel met me at the train yesterday. This morning in his class at the old California School of Fine Arts the whole muddled business of exposure and development fell into place. This afternoon I started to teach his Zone System. Ansel did not know it, but his gift of photographic craftsmanship was the celebration of a birthday." [1]

There are traditional placements that give realistic results from which the expressive photographer may deviate at will. This is Ansel Adams' description of the zones and some typical placements:

Low Values

Zone 0. Complete lack of density in the negative image, other than film-base density plus fog. Total black in print.

*Meters such as the Weston Ranger 9, the Soligor 1°, and the Pentax 1° spotmeters are rewarding in that they have viewing devices through which you can see exactly what area the meter is covering. The Weston 2, 4, 5, and the old Pentax 3° can be modified for easy Zone use. The Weston VI, Weston Ranger 9, Soligor 1°, and the Pentax 1° are still being manufactured, and may be simply adapted for Zone measurements. See Zone dials in catalogue section.

[1] Minor White, Mirrors Messages Manifestations, Millerton, New York, Aperture, Inc., 1969, p. 41.

1. Meter reading of flesh tone shows exposure value 12. The dial is rotated so that 12 is opposite Zone VI—the desired <u>placement</u> of the most important tone of the photograph. The indicated <u>exposure</u> is 1/15 at f/5.6 or 1/30 at f/4, etc. The dial is left in this position for subsequent readings.

2. Meter reading of background brings the needle to the number 13. 13 falls opposite Zone VII and the background will appear one zone lighter than the flesh tones.

3. Meter reading of black sweater shows 7. (Dial had to be switched to low scale.) 7 falls opposite Zone I and the sweater will appear nearly solid black with no texture.

Zone I.	Effective threshold. First step above complete black in print. Slight tonality, but no texture.
Zone II.	First suggestion of texture. Deep tonalities, representing the darkest part of the image in which some detail is required.
Zone III.	Average dark materials. Low values showing adequate texture.

Middle Values

Zone IV.	Average dark foliage. Dark stone. Landscape shadow. Recommended shadow value for portraits in sunlight.
Zone V.	Clear north sky (panchromatic rendering). Dark skin. Gray stone. Average weathered wood. Middle gray (18% reflectance).
Zone VI.	Average Caucasian skin value in sunlight or artificial light, and in diffuse skylight or very soft light. Light stone. Clear north sky (orthochromatic rendering). Shadows on snow in sunlit snowscapes.

High Values

Zone VII.	Very light skin. Light-gray objects. Average snow with acute side lighting.
Zone VIII.	Whites with textures and delicate values (not blank whites). Snow in full shade. Highlights on Caucasian skin.
Zone IX.	Glaring white surfaces. Snow in flat sunlight. White without texture. (The only subjects higher than Zone IX would be light sources, either actual or reflected; but they would obviously be rendered in the print as maximum white values of the paper surface.)*

*Ansel Adams, The Negative, Hasting-on-Hudson, New York, Morgan and Morgan, Inc., 1948, p. 19.

Students starting to use the Zone System often have some problems deciding which single value to choose for placement and where to place it. Experience soon resolves the difficulty and they begin to visualize in Zones. Minor White says he likes Zone IV toast. When I named my studio Zone VI (flesh tone), Ansel reminded me that angels should probably be placed on Zone VIII!

Here are some hints on placement that may help until your own experience in previsualization takes over. My procedure is to first look carefully at the subject, scene, portrait, etc., and decide if there is some value that <u>must</u> be on a certain zone. In a portrait, the flesh tone is the placed value because it is the most important value. (See illustration.)

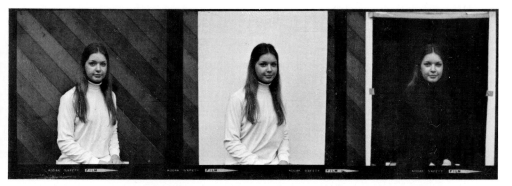

Average meter readings indicated three different exposures, but all three photographs were properly made at the same exposure — 1/30 sec. f/8, Tri-X Film — flesh tones placed on Zone VI. These are contact prints exposed together for the minimum time that would produce a maximum black of the unexposed film edge. Although the flesh tones seem lighter in the right hand picture, the effect is emotional and produced by the all black surround. Proof of identical exposures is seen by the consistent tone of the barnwood.

In a landscape mostly in shadow, I would place the shadowed area first, probably no lower than Zone IV. The same landscape in full sun might require a placement of the sun lit areas and the inconsequential small shadows might be of lower value than Zone IV. My rule is ''place the value you insist on'' and like most generalizations, it works most of the time.

The size and solidity of an object in the composition often influence its placement. While you could render a distant picket fence as brilliant white (Zone VIII), that placement would probably be too high for a solid white wall taking up considerable space in the composition. There is little texture in Zone VIII and the result would be dull. Zone VII would provide texture and give the wall a feeling of substance. (See illustrations on pages 14 & 15).

After one value has been placed, other important areas are read to see where they fall and a re-evaluation is sometimes in order. Sometimes the criteria for the picture might cause the photographer to change his original placement. For example, a full length formal wedding portrait for a dress manufacturer would call for a "placement" of the dress regardless of where the flesh tones fall. For the bride, I would make sure the flesh tones were correct. Actually, in this example lighting could be arranged to satisfy both if the photographer understands the Zone System.

Some form of the Zone System has been used—consciously or unconsciously— by every great photographer. Paul Mathews, who studied with Edward Weston, told me that Weston aimed his meter at sunlit dunes and it indicated an exposure of one second at f/45. Weston said, "I'll give three seconds". He knew from experience that the exposure indicated by the meter would result in middle gray.

The Zone System is no trick. It is solidly based on sensitometric principals which have been in effect since the first photographic exposure was made. Ansel Adams formalized the principals for fast and accurate field use.

Part of the total Zone System deals with variable negative development for increased control of individual exposures.* Unfortunately, this has caused many photographers who use 35 mm. or roll film to assume that the system can not be used by them. Variable development is a refinement; it is not the basis of the system. Placement of values on the exposure scale is the basis, and the principals involved come into play whenever a negative is exposed.

*See Ansel Adams, The Negative, Hastings-on-Hudson, New York, Morgan & Morgan, 1948, p. 98.

These principals apply to any film from X-Ray to color and the Zone System can be used to advantage with any camera that has exposure controls.

Rapid Exposure Calculation

Careful evaluation and placement of individual reflectances assures a precise exposure for a previsualized result. If the subject can not be closely approached and a spot meter is not on hand, or if time does not permit, an "emergency" metering method is available.

Quite accurate average exposures can be determined quickly by placing one value of known reflectance on its "proper" zone. By metering your palm and placing the result on Zone VI, you will record all values in the scene that reflect 36% on Zone VI. All values reflecting 18% will fall on Zone V and other values will fall on their related zones. Some photographers use a gray card and in that case, the placement would be on Zone V. The indicated exposure would be the same.

It is important to place the hand in the same light and parallel to the main planes of the subject.

Assume a photograph of sailing boats with the sun behind the camera. The hand is held vertically (parallel to the sails) and turned so that the reflectance angle is the same as the sails. With the sun behind the camera, those boats with sails at right angles to the camera will reflect more light than other boats. With side light, reflecting surfaces at about a 45% angle (midway between the light source and the camera axis), will reflect more light than those at right angles. These variables are taken care of if the reading is made as described.

This procedure is just as fast and far more accurate than average readings of mixed values of unknown reflectances.

To review: meter along the lens axis with your hand in the same light* as the subject and angled parallel to the main planes of the subject. Place the exposure value on Zone VI.

*If you are in open shade and the subject in sun, close down three stops on a bright day, two stops on a hazy day. If your hand is in sun, and the subject in shade, cast your body shadow on your hand or reverse the former procedure.

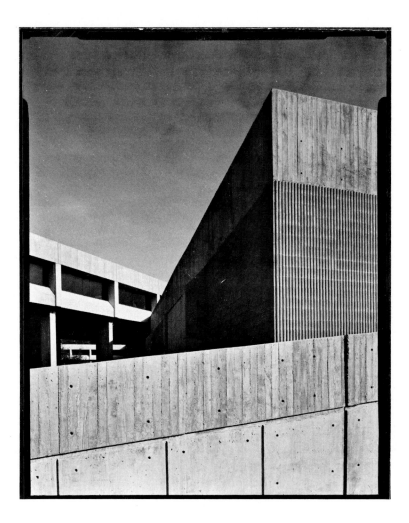

Clarkson College Science Center, Potsdam, N.Y. Courtesy of The Perkins and Will Partnership, architects. The poured concrete wall in the foreground was placed on Zone VII and shows adequate texture. Although the other surfaces are of the same material, they reflect other values because of differing reflective angles. A spot meter was used to measure these reflectances and a viewing filter indicated the necessary filtration to separate the various surfaces from the sky. The 90 mm. Super Angulon lens has a depth of field from 12" to infinity when stopped down to f/64 and focused at two feet. 4x5 Sinar camera with wide angle bag bellows, #12 (medium yellow) filter. Straight contact print on #2 paper.

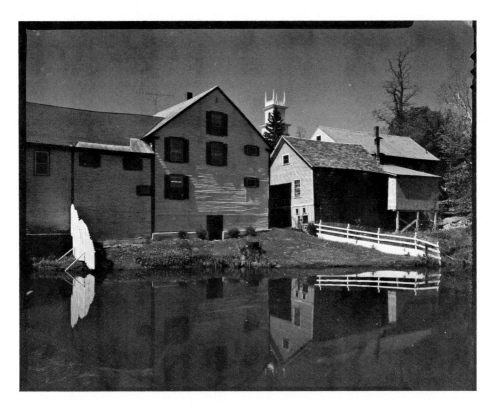

Putney, Vermont. The shaded side of the left hand building was placed on Zone V. The left hand fence fell on Zone VIII and shows slight tonality. The right hand fence fell on Zone IX as do the church spires. They are pure white and add brilliance to the print. All reflections in the pond are about one Zone lower. Pure black appears only in the small area under the raised structure on the right. Small areas of total black and pure white add vitality to any print. Original visualization included cropping of the foreground up to the reflection of the left hand fence. Two identical negatives were made for insurance against possible negative or processing defects which would show clearly in the smooth sky area. Straight contact print on #2 paper.

THE IMPORTANCE OF PRECISE EXPOSURE

There is a general misconception that a real dark-room wizard can make a fine print from a negative one or two stops under or overexposed. In the book "Photographic Sensitometry," Zakia and Todd demonstrate conclusively that there is virtually no latitude in film exposure for optimum print quality.

"For a pictorial subject, printed by projection, a plot of print quality (as estimated by a panel of viewers) versus exposure index level indicates that there is an optimum ... latitude in exposure (the phrase implying that there is a tolerance in camera exposure) exists... only if some sacrifice in print quality can be accepted. For nearly the best possible print, the tolerance is very small indeed."*

Is such precise exposure really that important? Would a one stop under or overexposure make a difference that could not be handled in the darkroom? Let's take a close look at what really happens.

Overexposure When film densities from increasing exposures are recorded on a graph, the path extends in a straight line from about Zones III through VII. That means that for each increase in exposure there is a corresponding increase in negative density. Subject values falling on those Zones are well separated. Above Zone VII, increased exposures do not increase negative densities proportionately. The "characteristic curve" flattens out and this region of the curve is called the "shoulder." With even slight overexposure, the high values will "pile up" on this shoulder and delicate separation in the print will not be possible. (See illustration).

Underexposure The bottom of the characteristic curve (H. and D. curve) is long and low and Zones I to III fall on it. The separation between these low densities on the toe is much less than the separation between straight line densities. Underexposure reduces this separation further and causes values that should appear in the print to fall below exposure threshold. Those areas will be blank in the negative. A print from an underexposed negative will

*Hollis N. Todd, and Richard D. Zakia, op. cit., p. 169.

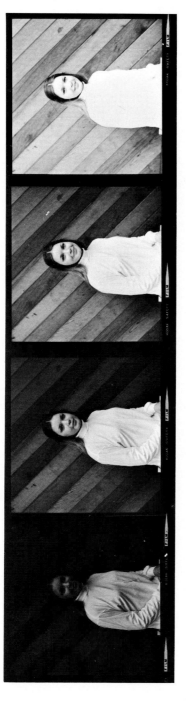

Note the absence of exposure latitude in even this low contrast (open shade) situation. One stop overexposure—the third frame—blocks the shirt and compresses the flesh tones.

One stop underexposure—the first frame—would require a shortened print exposure to produce acceptable flesh tones. Shortening the printing exposure would result in an absence of a good black and the print would be weak and muddy.

120 Tri-X rated ASA 200 was exposed with flesh tone placed on Zones V, VI, VII, and VIII. Printing exposure was the minimum that would produce a maximum black through the clear film edge.

17

also show the high values too low if sufficient printing exposure is given to achieve a rich black. To retain the black and raise the high values, paper of high contrast is often used. The result is a harsh print without substance in the low values — a poster.

Some latitude in overexposure does exist in certain short range situations, but it is slight. (See illustration).

Exposures differ by one stop. Frame 2A could be printed down to the approximate values of frame 3A, or any intermediate value. The other frame could not be printed lighter to match frame 2A without losing black as the contact print was given the minimum exposure to record the film edge black.

DETERMINATION OF PERSONAL FILM SPEED

In order to achieve previsualized exposures, it is necessary to determine the proper meter setting for your film, your meter, your shutter, etc. This setting can only be determined by performing a test with your equipment. The test, described below, is easy. The result is a film speed tailored to your equipment.

> *The proper ASA speed rating is the one producing the minimum printable density of a Zone I exposure. That density is .08 to .10 above "film base plus fog." **

The reason that we test for Zone I is that exposure below exposure threshold (Zone Zero and below) results in no density other than unexposed film base.

The proper Zone I density is accurately determined by a machine called a densitometer. Photo laboratories and some printers have densitometers,** but if you have trouble finding one conveniently, you may send the film to me and I will indicate which negative has been exposed at the proper meter setting. (See "Advisory Services").

My experience in checking the tests of workshop students indicates that in about 80% of the cases, 35 mm. Tri X must be rated lower than ASA 400 to get the necessary density in Zone I. In many cases it was rated as low as 100 but occasionally as high as ASA 600; possibly because of slow or fast shutters, differences in meters, or any of a dozen combinations of factors.

My Tri X rating for my Weston and my Nikon and my other equipment and procedures is ASA 200 which is 1/2 the manufacturers rating. I have access to an electronic shutter speed tester and my shutter is close to accurate.

*Unexposed processed film (film edge) has density that ranges between approximately .10 (roll film) and .30 (35 mm. film). This base density is called "film base plus fog."

**Make sure the densitometer is checked by the use of a calibrated step wedge--a "negative" calibrated by the manufacturer in accordance with known densities. If the density indicated by the densitometer is .10 when measuring an area of the step wedge known to be .08, the densitometer is adjusted to .08 by slight adjustment of the zeroing knob. Do this immediately before reading the negative and check it immediately after to make sure dips in line voltage, etc., have not affected the reading. Repeat for each negative.

My rating for 4 x 5 Tri X is higher--ASA 320 which happens to agree with the manufacturer's rating.

My rating for 120 Panatomic X is 64 which is double the film manufacturer's rating.

For Tri X 120,* my rating is 200--one half the manufacturer's rating.

Do not use the above settings. They probably will not work for your equipment. I list them only to show typical variances from accepted standards and the necessity for testing.

Once you have completed the following test your personal film speed will be determined. This speed should not be changed unless you change equipment or materials. In that case, you will need to retest.

Film Speed Test Procedure

Set your meter-in-camera or your hand-meter for manufacturer's recommended ASA film speed. Tripod the camera and point it at any smooth (not clapboard) single-toned subject in even steady light. Steadiest light will be found on a cloudless day. You might place a large card board or sheet of painted plywood on the shady side of a building.

Meter the cardboard making sure that the meter is facing it directly. Meter along the lens axis. Make sure that the meter is not reading any other value but the cardboard. One foot away from a 16 x 20 card is good insurance. It is important that your meter or your hand do not interfere with the open skylight falling on the test target. If you are too close, you will see a soft edged shadow even in full shade.

*The 120 roll film that I use is not the Tri-X Professional rated by Kodak at ASA 320. It is the regular Tri X rated by Kodak at ASA 400. My test of these two films resulted in an .08 density for Zone I at a meter setting of ASA 200 for the regular film and only ASA 75 for the professional. Same camera, same shutter speed, same meter, same lighting conditions, etc. The films were developed together in the same tank.

Bring the camera close enough to fill the frame with the target and make sure the camera is facing the target straight on. Focus on infinity as we don't want textures for this test.

Since even panchromatic films are not as sensitive to artificial light as to daylight, your test will be inaccurate (about 1/2 stop) if you use flood lights, etc.

If you have a Weston meter with a Zone dial, just rotate the dial to place the needle reading opposite Zone I. Choose a shutter speed and aperture combination from the opposite side of the dial and expose. Use a normal speed such as 1/125 or 1/250. You can choose a lens setting between f stops but shutter speeds must be set on a number.

For other meters and camera meters, set your lens for the indicated aperture and shutter speed. You have set Zone V. To get a Zone I setting, close down the aperture four stops. If you run out of stops, start with a higher shutter speed* and appropriate larger lens opening. It will help to recite aloud as you close down--"Zone IV" (close one stop), "Zone III" (another stop), "Zone II" (another) and "Zone I" (final stop). Make the exposure. Change the ASA speed setting on your meter to twice the manufacturer's recommendation. Make another Zone I exposure. Make a third at 75% of the rating, and another Zone I exposure with the meter set for 1/2 of the rated speed of the film. The next exposure is made with the meter set for 1/4 the ASA rating. Expose the rest of the roll to Zone V or take pictures.**

Develop these negatives with any developer for your usual or manufacturer's suggested time. The low (dark) values are relatively unaffected by type of developer or developing time, so future changes in developer will not require another test for ASA speed. Development materials and procedures are described in a later section of this book.

*If you run out of speeds for the highest ratings, bring the card indoors and position it on a wall opposite a window or use a darker card.

** Developer action would be greater than normal if a given quantity of developer had only a few exposed frames to work on.

After development, find the negative with a density of .08 to .10 above film base and fog or send the film to me if you can't locate a densitometer. Keep careful notes so that you can identify the negative I mark. There are charts in the back of this book where the information should be entered. Use a separate chart for each size or type of film.

After your personal film speed is determined, only one more variable remains uncontrolled--the normal development time for your enlarger's contrast characteristics, your paper, developer, etc. The test to determine the proper time is described in a later section. The optimum development time .cannot be determined until the film speed is known.

FILMS AND DEVELOPERS

There must be hundreds of combinations of films and developers. I tried many combinations until I received a letter from Liliane DeCock several years ago. She said that Ansel Adams was making prints from 35 mm negatives that looked almost like they were made from 4 x 5's. Liliane was Ansel's assistant and an outstanding photographer and printer. If you've never seen an Ansel Adams print, you may not know the technical and esthetic capabilities of black and white photography.

The film and developer combination that Ansel Adams used was Tri X and HC110 (Kodak). I have used this combination for several years for nearly all of my black and white work in 35 mm, 120 roll film, and 4 x 5.

In 1970, the magazine International Photo Technique, published in Munich, contained an article by Fritz Meisnitzer which stated:

"The results were very surprising. In fact, I was so surprised that I repeated the test but obtained the same results again. Straight away the HC110 developer seemed to be the most suitable in all cases. It resulted in a higher resolution in the case of all three emulsions of the fine lines of the Schumann hexagon and

also led, viewed at normal reading distance, to a more contrasty and hence sharper image of the test object. Since the conditions were identical for all exposures, one can only come to the conclusion that, in comparison to Microphen, HC110 can obtain a higher resolution and better contrast from all three emulsions. The consequences are clear: the finest details are rendered more clearly and by virtue of the better contrast such details dominate to a greater degree over the structure of the grain. We thus have the preconditions for the rendition of clear, sharp details.

Nevertheless, this was not what caused the real surprise. It came to light when I subjected the various emulsions to a magnifying glass. And if the printed results are not capable of showing the last nuance of detail, then you will have to either believe me or carry out a test yourself. The highest resolution and the best contrast were shown by Tri X--the most sensitive of the three emulsions and from which one would never have expected it. The second place was taken by Plus X-Pan and the third place by Ektapan.''

It is, I think, important to realize that the laboratory test results of any photographic product might be exciting, but if the product had the qualities described in a test but lacked other qualities, it might be unsuitable for certain expressive requirements. We don't photograph Schumann Hexagons and Siemens stars, but surf and people, rock and sky. Products must be chosen that under field conditions achieve the results that the photographer envisions. In the case of Tri X with HC110, I find the field results as impressive as the laboratory tests.

High Speed Developers

It has been my experience with so-called high speed developers that the increase in density does not take place in a linear (equal for all zones) manner, but has its greatest effect where it is least wanted--in the higher values. The dense high values require overlong printing times to achieve some texture. This over-printing will result in loss

of detail in the thinner areas. The same effect is achieved by overdevelopment with any developer.

"The phrase 'forced' development is used by photographers to mean increased time or developer activity beyond normal, the intent being to increase the effective exposure index. For black-and-white negative materials, such efforts have the effect of increasing total negative contrast and highlight density, with comparatively little effect on the shadow areas which are without detail even with prolonged development. There is good experimental evidence to show that forced development causes only a minor improvement in the quality of an underexposed negative, and that this improvement exists only for scenes of low contrast. Similar statements apply to esoteric developers that claim 'speed' increases."*

Development by Inspection

After about half of the normal film developing time has passed, the photographer utilizing this technique turns on a very dim green safe light and pulls a few frames from the reel. He has only a few seconds to look at the thick creamy film. During that time, he decides how much more development the film needs. I can't tell a Zone V density from a Zone VI with the clean dry negative on a light table, but assuming he can tell the difference in the dark, how does he know whether the negative of the horse he is looking at was the white one (Zone VII) or the black one (Zone III)?

Develop by time and temperature and be consistent.

*Hollis N. Todd, and Richard D. Zakia, op. cit., p. 179.

DEVELOPMENT PROCEDURES
FOR 35 mm AND ROLL FILM

The personal development time that will insure the previsualised result is as important as the film speed test. Generalisations regarding development time can not be made because of differences in the contrast characteristics of papers of different brands, print developers, enlarger types, and even enlarging lenses. There is a procedure for determining a personal development time that will take care of these variables, but the test can only be carried out after the Zone I negatives have been processed and the film speed determined. The test is therefore described in a later section. This section deals with general developing procedures.

Tanks, Reels, and Loading

Your room must be absolutely dark. A room that seems dark may spring a lot of leaks after you have been in it for a few minutes and your eyes have become adjusted to the darkness. If in doubt, a light proof changing bag is the answer.

No safe light is safe with modern panchromatic films. There is, however, no problem with radiant dials on timers or radiant pull chain ends, tape, etc.

I have always used the stainless steel tanks and reels with good results. I use the film loader that snaps on to the reel, cups the film, and guides it into the spirals of the reel. It keeps my fingers off the film and it is fast and positive. The simple directions come with the loader. For 120 size, it is easier to position the film on the reel if, after peeling the paper backing from the sticky tape that connects it to the film, you fold the tape over the end of the film. This acts as a stiffener for the flexible 120 film and is fed into the clip on the reel. Wiggle it left to right to make sure it is centered on the reel before starting to wind. 35 mm film will center itself if you cut off the narrow leader before loading.

If you haven't developed film before, it is worth while to waste a roll of film by loading it a half dozen times in the light and then in the dark. The important thing is to get the first turn on the reel properly set in the steel spiral. The rest is easy. As you turn the reel, hold it at the outer rim. When you reach the end, cut off the spool (35 mm).

Put the film into the tank and put on the cover. When developing one reel in a two or more reel tank, the empty reels must be added to prevent the film from rushing through the solution during agitation periods. The room lights can now be turned on. The tank is light proof but solutions can be poured in and out through the small opening. Set loaded tank aside.

Temperatures and Solutions

Turn on the hot and cold water and let it run until the temperature stabilizes. Put a graduate under the flow with a thermometer in it and adjust the hot and cold taps until the water is running at 68°. Thermometers may vary widely and the effect on development time is extreme. For example, developer action at 68° for 6-1/2 minutes equals 75° for 4-1/2 minutes. If you have doubts we can check your thermometer. (See Advisory section).

In hot weather 68° may not be possible. The instructions with the film or developer will indicate the shorter development times required for higher temperatures. Fill a print tray with 68° water and put the fixer bottle in it to raise or lower the fixer temperature to 68°. Leave the water running into the tray at 68°. Now mix the developing solution. Kodak's directions for diluting HC110 and then diluting the dilution have caused many errors among students. I use the "B" dilution which is one part HC110 to 31 parts water and to avoid errors, I carefully pour one ounce* of developer concentrate into a small graduate. It is easy to be precise if you use a 1-1/2 or 2 oz. graduate. Pour the ounce of developer into an empty one or two quart graduate. HC110 developer has a maple syrup consistency, and because it is so concentrated, it is important to get every drop into the large graduate. Pour a little water into the small graduate being careful that it doesn't overflow. Place your palm over the small graduate and shake well.

*These measurements assume a 32 oz. tank. For 16 oz. tank, halve all measurements.

Empty it into the big graduate and repeat two or three times. Add water (68°) to the graduate up to the 32 oz. mark and stir until the solution is uniform. Place the graduate in a print tray containing 68 ° water.

Presoaking

Fill the tank with plain water through the small opening. This serves to presoak the film for more even developer action, and also removes any dust that may have got on the film while it was being loaded on to the reels. Rap the tank sharply against a table top or sink rim 2 or 3 times to dislodge air bubbles that may adhere to the film. Agitate by inverting the tank 4 or 5 times, then take off the small cap and pour out the water. Total time of presoak is not critical, but a minute or so is fine.

Development

Set the timer for manufacturer's recommended time and pour the developer in.

Pour it right in. It goes in faster if you tip the tank a bit. Recap the tank and rap it 3 times as before and then agitate gently by inverting the tank with your right hand, set it down and invert it with your left and continue for 15 seconds.

Four minutes and 45 seconds are left on the timer.* Put the tank in the tray for 15 seconds and then invert once to the right and once to the left and put the tank back in the tray--repeat every 30 seconds. Between agitation periods rinse out both graduates and put 31 oz. of water in the large one. Add one ounce of 28% acetic acid and stir. When time is up, take off the small cap and pour out the developer-- down the drain. This developer is used just once.

Stop Bath

Pour in the acetic acid stop bath to halt the developer action and agitate continuously for 30 or 40 seconds. Pour the stop bath down the drain.

*Assumes 35mm Tri-X with HC110 at manufacturer's recommended time of five minutes.

Fixing

Pour in the fixer, agitate for 15 seconds continuously and then a left and right inversion every 15 seconds or so. After 5 minutes total fixing time, pour the fixer back into the bottle and take off the big tank cover.

Washing

Place the tank under the tap allowing the 68° water to run in and overflow. Mark the fixer container with four marks with indelible pen to indicate 4 rolls processed. A quart of Kodak Fixer will handle ten rolls before exhaustion.

Grasp the tank across the top so the reels don't slide out, and invert to pour out the water. Refill and repeat a few times.

Washing Aid

Thorough washing is speeded by use of a washing aid such as Perma Wash or similar products. Fill the large graduate with 31 ounces of water and add 3/4 ounce of Perma Wash, stir until uniform and pour it into the tank. Swish it around or rotate the reels for one minute with your finger. Pour the solution down the drain and place the tank under the running water again. Dump it occasionally. After 15 or 20 minutes, the film is washed. Pour out the water.

Fill up the graduate (32 oz.) with distilled water* and add 1/2 capful of Kodak Photo-Flo 200. Pour into the tank, swish it around, and pour back into the graduate after 45 or 60 seconds for later use. The last is a wetting agent and with the distilled water (available in supermarkets for 60 or 70 cents per gallon), will give you sparkling clean negatives.

*One day while photographing a water treatment plant, I asked the engineer about the chemical quality and consistency of the town water. His answer caused me to buy an "Aquastill" and I now use distilled water for all solutions including film developer, print developer, stop bath, fixer, Perma Wash--everything except the running water wash.

Drying

Hang each film by a clip and add a weighted clip at the bottom. Dip a <u>clean</u> sponge used for no other purpose into the Photo Flo solution in the graduate, wring it out and holding the weighted clip to keep the film taut, wipe each film once from top to bottom, front and back, <u>gently.</u> Rinse the sponge, wring it out and put it into a polyethlene sandwich bag.

The film may feel dry in an hour, but the emulsion has not "set." Depending on humidity conditions in your area, five to eight hours drying time is indicated before handling. Overnight is always safe. The room where the film is dried should be as dust-free as possible and of normal (68° to 75°) temperature. Heat drying is not recommended, nor is an area where people are moving about raising dust.

SHEET FILM PROCESSING

Before loading sheet film it is vital that the holders be completely clean. If there is a speck of dust anywhere in the holder, it will somehow gravitate to the emulsion side of the film and center itself in the smoothest tone of the future exposure--the sky. Since it shields the film from exposure, the result in the print will be a jet black crescent, worm, dot, etc.

I've tried "lint free" anti-static cloths, damp sponges, brushes, and finally found one thing that works--the tank type vacuum cleaner. Put on the small vacuum cleaner head and vacuum the table you are going to work on. Pull out the slides and vacuum the holders including the slots the slides insert through. If you angle the vacuum head correctly, you'll hear a screaming whistle as the air whips through the slots. Vacuum the slides on both sides and insert them in the holders silverside out. Before you load, vacuum the counter in the darkroom. Wash you hands and dry them well on a clean towel.

Lights off. Kodak says lay the sheet films on top of the closed box, emulsion side up, notches in the upper right corner. I put them in the box crossway so the notched end sticks up above the box, notches in the upper right corner. That way you won't knock them all over the counter top and floor, nor will you get your fingers on the emulsion feeling for the next sheet. You'll feel the box. You load the exposed films back into the box the same way (crosswise). Laying them on the counter edge as generally recommended is disastrous. They will fall on the floor in the dark.

Sheet films are developed either in trays or tanks. Tanks may be feasible if you are developing a large number of films. For fewer films, trays seem more convenient. I use 8 x 10 FR Printrays as they are provided with deep grooves so that you can easily get your fingers under the films to agitate them.

From left to right in the sink the trays contain:

1. Plain water
2. 1-1/2 quarts (48 oz.) HC110 "B" developer
3. 1-1/2 quarts (48 oz.) stop bath
4. 1-1/2 quarts Kodak Fixer
5. an 11 x 14 tray with running water for wash--all solutions at 68°.

The trays (except wash) are all tipped toward the front of the sink by a strip of wood 6' long by 3/4" square. The long side of the trays is parallel to the front edge of the sink. I develop no more than fourteen 4 x 5's at one time. That is less than 1-1/2 quarts of HC110 dilution "B" can develop before exhaustion, and it is as many films as I can agitate carefully during a 30 second period.

If you are doing it for the first time, start with no more than 3 films and make a dry run with blank films. My normal developing time for 35 mm Tri X and HC110 is in accord with Kodak--5 minutes. Their suggested time for Tri X sheet was 4-1/2 minutes* in trays. My normal time is 7 minutes. A procedure for finding proper developing time is in the next section.

When all solutions are prepared and the water running into the wash tray, wash your hands and dry them well on a clean towel. Set timer, lights out. Unload the holders into

*Latest Data Sheet (Revised 3/71) says 9 minutes!

the box as described. Take the stack of films out of the box with your left hand and hold them by the edges. Separate the top film at its upper right corner from the rest with your right index finger, grasp at the corner and lay flat on the water in the first tray. Extend your little finger and gently submerge the film. The film must be completely submerged before you lay the next one on it or the two will weld themselves together. You must also keep your right thumb and index finger dry by dropping the film the last inch or the same thing will happen to the films in your hand. Your little finger touching the water tells you when to drop. Once the films are individually submerged, they won't stick. When all the films are in the water, feel under the stack and take the bottom sheet out of the tray (sliding it to the right). Lay it flat on top of the others. Push it gently under with the side of your left thumb.

Go through the pile twice this way taking your time and being careful. The films must be laid flat on the water or the corner of the one on top may damage the emulsion of the one underneath it. When you are doing it right, you will hear a small ''splat'' as you lay the films down. Start the timer and pick up the whole stack and transfer it to the developer which is in the tray to your right. Agitate continuously until time is up and then put the stack of films into the stop bath to your right. Agitating through the pile twice will take 30 to 60 seconds. Then put films into the fixer and continue to agitate for 5 minutes. Lights on. Don't stop to admire or inspect. Get them all into the running water tray.

Pour the solutions down the drain and wash the trays in warm water. Prepare a Perma Wash solution and agitate the films in it for one minute. Before putting the films back into the running water tray, empty and rinse it to remove all traces of fixer. Fill it up again and return the films. Wash for 20 minutes moving the films about occasionally and gently empty the tray every 5 minutes or so. Make up 1/2 quart (16 oz.) of distilled water in a tray with 1/4 cap of Photo Flo.* Turn another tray upside down, rinse it well and place a sopping wet clean sponge on it. Take out a negative, lay it on the sponge and slide it across, turn it over and do it again on the other side, rinse off front

*This is ½ manufacturer's recommendation.

and back under running water and put it in the Photo Flo solution. When you have three negatives in the Photo Flo, take out the first one from the bottom and clip up to dry on a wooden clothes pin* at the corner where the notches are. That's where the sky is and it's better to let the water drain to the more mixed tones of the foreground area, just in case. 8 x 10 films should be sponged off, 4 x 5's don't need it.

*Clothes pins are usually suspended from a wire stretched across the room.

NORMAL DEVELOPMENT TIME TEST

Up to this point we have discussed development pro-
cedures in general. The Zone I exposures have been proc-
essed and a personal ASA speed has been established.

The density of the lowest values is almost entirely the
result of exposure and increased or decreased development
time has practically no affect on these densities. The
values above Zone V however, are strongly affected by
increase or reduction of development time. To perfectly
tailor your negatives to your enlarger, paper, and materials
requires a development time test to insure that higher
values will also appear in the print as they were placed at
the time of exposure.

The Zone I exposure test has properly recorded the
low values. The Zone VIII development time test will in-
sure proper negative densities for the high values.

*The proper development time is that which will render a
Zone VIII placement as a Zone VIII print value. (Assumes ex-
posure at proper ASA rating and a printing time in the enlarger
that is the minimum required to produce maximum black through
clear film.)*

Workshop tests have shown that many students' proper
development times deviate more than 25% from manufac-
turer's recommended times.

The possible variables are infinite. I recently attended
a workshop in Millerton, N.Y. and found that the negatives
that I developed there were of considerably higher contrast
than usual. The water in Millerton has a high iron content
and that might be the reason for the increased developer
action.

Development time can be determined only after the
ASA speed has been ascertained.

What we will do is make 3 series of exposures at the proven ASA meter setting and develop each set for varying times. Then we will print the Zone VIII negatives to determine optimum developing time.

A similar setup as the one for the film speed test is used. This time, Zones VIII, VII, and VI should be recorded with the card in sun; the lower Zones with the card in shade. Theoretically this is not necessary, but some meters do not register in a linear manner for varying light intensity so this approach is worthwhile to duplicate field conditions as closely as possible. (Sunlit areas are almost always placed on one of these Zones while shadows are generally recorded on or below Zone V.)

The meter is set for the proper film speed--the speed that produced the proper density for Zone I exposure.

Meter the card and expose 8 frames--Zones I through VIII. 35 mm. film users expose all remaining frames except six* to Zone V or take pictures. Remove film from camera and repeat with two more rolls. Sheet film users also make three sets--24 negatives plus one unexposed negative.

Develop one roll for the manufacturer's recomended time.

For sheet film, develop one set and the unexposed "negative."

Fix, wash and dry the film as usual.

Set your enlarger for about an 8 x 10 print. Place the unexposed negative in the enlarger. This negative is actually a Zone Zero and properly appears as maximum black in the print. The next step is to find the minimum printing exposure time that will produce a maximum black.

Set the lens to f/8 or f/11, the timer to 3 seconds, and turn off the white lights. Place an 8 x 10 sheet of your regular enlarging paper (#2)**on the easel and give it a 3 second exposure. Now cover about one inch of the right hand side

*Leave blank. They will be used for a later test.
**With variable contrast paper, use no filter.

of the paper with a card and expose again. Move the card another inch to the left and repeat in this fashion until you reach the end of the paper.

There are now 8 or 10 exposures each 3 seconds greater than the preceding one.

Develop the print exactly 2 minutes, stop bath, and fix. (A later section of this book deals with development of prints in more detail.)

After 30 seconds in the fixer, turn on the white lights and locate the first stripe that has produced a maximum black. This is the stripe that is not different than the more exposed stripes that follow it. That stripe should be near the center of the sheet of paper. If it appeared before 9 seconds (the third stripe), close the lens one stop and repeat the exposures. If it appeared after 24 seconds, (the 8th stripe), open the lens one stop and repeat. After the exposures are made, do not disturb the enlarger. We need to keep all settings constant.

Fix the print normally, wash and dry. All papers dry down (get darker) in varying degree. The stripe that appeared a very dark gray when the print was in the fixer may dry down to a solid black. Only when the print is dry can you determine exactly the time required for the first maximum black stripe. We will assume for this test that pure black first appeared in the fifth stripe--15 seconds.

Now put the Zone VIII (densest) negative in the enlarger and another sheet of paper on the easel. Cover 1/2 of the paper with the card, and give five 3 second exposures. We are repeating the exact procedures of the maximum black test so it is important not to change the timer, focus, lens opening, paper, or anything. Develop 2 minutes and fix. Turn on the white light.

If the negative development time was correct, you will see a slight tonality barely darker than the shielded portion of the paper which is pure white. If you see no difference between the shielded portion and the exposed area, the negative was overdeveloped. Develop the second roll 25% less and test the Zone VIII negative—by giving the same 15 second enlarging exposure.

If the difference is more than very slight (a very pale gray), the negative was underdeveloped and the next roll is developed 25% longer and the test repeated. If the print looks right, or a bit too light, wash, dry and recheck.

With luck, you will get a perfect Zone VIII print value on the second attempt. It is unusual to get a match on the first attempt. The third try either works perfectly or is so close that it is possible to closely approximate a developing time that would result in a Zone VIII print value.

To be positive, make a Zone VIII exposure on your next roll of film and develop for the projected time. One print with enlarger and timer settings as before will indicate whether or not your calculation was accurate. Fill in the developer and time sections on the chart in the back of this book. Use the same chart that contains the exposure information for that film.

What you now have is your optimum negative. Your negative has just the right exposure and just the right development to:

1. Print values below Zone I as maximum black.
2. Print Zone I exposures as Zone I print values.
3. Print Zone VIII exposures as Zone VIII print values.
4. Intermediate tones will print as placed.

All of the above occur at the minimum enlarging exposure that will render the paper maximum black. It is the thinnest negative (and therefore the best) that will do the job.

Next, print the other negatives (Zones I through VII) that are on the roll that received the proper development time. They too must get identical exposure and development to that used for the maximum black and the Zone VIII print.

You now can see eight prints from the least density that will register on the paper (Zone I) to the most density that will register on the paper (Zone VIII). Write the Zones on the back of each print.

From now on, any subject, in any light conditions, anywhere placed on any zone will match the shade of gray in the print you have made of that Zone.

At this point you have achieved a superior technique for exposure and development of negatives. Don't be distracted from your hard won technique by the man in the camera store or other "experts". Insist on looking carefully at prints before acting on anyone's advice. Real experts are rare, but easy to identify. They impress you with prints, not conversation.

Standardization for Consistent Results

Concentration and effort have been expended and complete control obtained if you have completed the tests to this point. Once you have standardized your materials, chemicals, equipment and methods, stick to the same procedures and materials. Haphazard trying of one product after another virtually guarantees destruction of photographic craftsmanship.

If a new light meter or thermometer is purchased, it should be matched and adjusted to the one used for tests. Adjusting the ASA speed until both meters give the same camera setting information when reading the same surface will insure uniformity of future exposures.

If you change film, film size, or developer, you must retest for speed and developing times. If you are using more than one camera you can have the shutter speeds checked to see if they agree. If not, the meter is set at a different ASA rating for each camera. Apply a sticker so you will remember.

THE PROPER PROOF

A properly made proof sheet is an invaluable printing aid as it contains all the information about the negative with respect to exposure, contrast,* and composition. I never attempt to print a negative until I have made a proof. In addition to filing and selection information, a rigid proofing procedure can be a constant check on meters and camera shutters and any manufacturing changes affecting film speed or contrast characteristics.

Test for Proper Proof Exposure

Put any negative in the enlarger, set up for about an 11 x 14 print and focus. Mark the enlarger column with tape or magic marker and a corresponding spot on the movable head so that you can find this exact elevation in the future. Remove the negative and replace the empty negative carrier. Position the proofer** (contact printing frame) in the center of the light cast on the countertop or easel. Stop down the lens to f/8. Turn the enlarger off and set the timer for three seconds.*** Lights out except safe lights. Place a sheet of your normal enlarging (not contact) paper face (shiny) side up on the open proofer. Use your regular enlarging paper #2 grade or if variable contrast paper--no filter. Now lay the strip of unexposed (but developed and fixed) film dull side (emulsion side) down on the paper. Use the blank film from the development time test.

Close the glass over all and give a 3 second exposure. Cover the right hand end of the film (about an inch) by laying a cardboard on the glass and give another 3 second exposure. Continue moving the card one inch to the left between exposures until you reach the end of the film.

*A contact print will have far less "contrast" than an enlargement made with a condenser enlarger. More on this later.
**The proofers that cover the film edges with guides defeat the purpose of showing the film edge black.
***This exposure time will be different from the last test. This time we are printing through glass and at a greater magnification.

Remove the paper and agitate it constantly for 2 minutes in your print developer (I like Dektol diluted 1-2 as directed). Agitate in stop bath (1-1/2 oz. of 28% acetic acid per quart--a 50% stronger solution than for film) for 20 or 30 seconds, then into the fixer (Kodak Fixer). Agitate for 30 seconds and turn on the room lights. You will see gradations from light gray to jet black in one inch stripes across the film. Locate the stripe that is the first one to match the next one in blackness. As in the film development test, we want the minimum exposure that will produce the maximum black through the clear film. Identify the first completely black stripe--not the very dark gray one next to it. This will vary with the brand of paper, enlarger, illumination, lens opening, etc. If the time is under 9 seconds, retest, closing one stop to refine the result. If over 24 seconds, open one stop and retest. Fix, wash, and dry and then locate the first maximum black stripe.

Write down all information on the chart in the back of this book.

Other films or other sizes of the same film will require different proofing times due to varying base densities. Test them all. Write them down on separate charts.

This is now a standard for this film and all future proofs are made exactly the same.

To make an actual proof, substitute negatives for the clear film used for the test and give the negatives the exposure you have written on the chart.

The proper proof will tell you all about your negatives. I know a professional whose proofs all show the film edge as gray. He has been underexposing his negatives--for years.

Use of the proper proof makes it simple to determine the precise guide number for any old fashioned* flash unit.

*The new automatic electric eye flash units are committed to middle gray. They shoot out the light and when "enough" bounces back they shut themselves off. The electric eye always delivers the same amount of light to the film. To prove this, aim your camera and the flash gun at a white seamless backdrop or wall about six feet away and make an exposure. Make another exposure of a dark wall ten or 12 feet away. The resulting negatives will have the same density and will print middle gray. The only way to outsmart these robots is to change the ASA film speed setting. If you halve the ASA setting that gives middle gray, you'll get Zone VI (the white wall); double it and you'll get Zone IV (the dark wall). If you use it without adjustment, a person standing in front of the dark wall would be overexposed; in front of the white wall, underexposed.

To test an electronic flash unit, place the light exactly 10 feet away from the subject. Most focal plane shutters will not synchronize at speeds over 1/60 of a second though a few will work at 1/125. Check your camera instructions. If in doubt, use 1/60 or slower. Leaf shutters synchronize at any speed. Set the camera control at "X" (not "M"--that is for flash bulbs). Expose with the lens wide open, close a stop, expose, another stop, expose, etc. down to the smallest opening.

After development, make a proper proof. The correctly exposed negative will be obvious. If it was the f/8 negative, your guide # for this film is 80-- f/8 times ten (feet). Write it on a label and attach it to the flash unit.

Proper filter factors are found the same way. (See illustration.)

THE CORRECTED PROOF

In order to compensate for uneven exposures, some photographers make "corrected" proofs. First, he may make a proof and find that two negatives are "overexposed." (He may pull it out of the developer in 30 seconds because it's getting too dark too fast--or leave it in 5 minutes) and two are "underexposed." The rest are o.k.--maybe. If 12 seconds were the minimum time required to get black through the film edge and he gave eight seconds, perhaps the two "overexposed" negatives are the only decent ones. The bad negatives get more doctoring by "dodging" and "burning." By now, there is no way of telling what the negatives are really like.

Don't "correct" a contact sheet. If a negative looks bad after your proper proofing, it is because it is bad. The proper proof will reveal exactly what a negative is. Don't defeat its purpose.

THE CUSTOM LAB

Toward the end of my first year of photography, I met a staff photographer from Life Magazine who told me I had a good eye, but didn't know how to print. I hoped he was right about the eye. I knew he was right about the printing because I could see for myself that the Weston and Adams

40

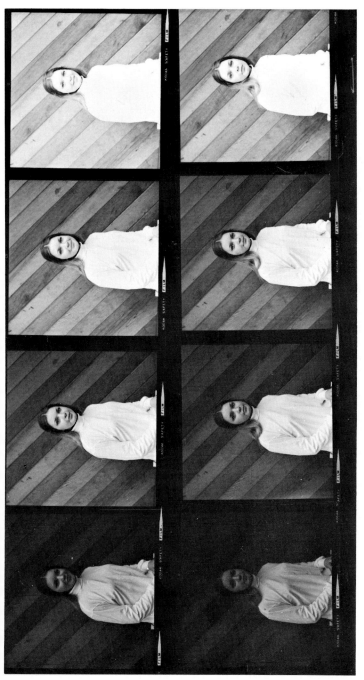

The proper proof identifies proper filter factors. Upper row with Rollieflex medium yellow filter; first picture was made with flesh tone placed on Zone VI and no allowance for filter. Each succeeding picture was given one more stop. The second picture is correct (Zone VI flesh tone). The factor therefore is two — twice the indicated exposure (one stop).

Second row was made the same way but with a medium green filter. The Zone VI flesh tone appears in the third print. The factor is four (two stops) for that filter.

prints at the Museum of Modern Art glowed with a quiet brilliance. My prints were crude--too black, too white, harsh without brilliance or flat and drab. I changed papers, I changed developers, I bought a $500 enlarger--the wrong one.

The neighborhood camera store man suggested I hire a professional to teach me so I called an expensive custom lab. They said I could watch their best printer for $15.00 an hour if I didn't distract him. For that price I was not going to miss anything, so I took notes on his procedure.

He pinched the sides of his nose between thumb and forefinger to get a little skin oil and drew a 35 mm negative through his fingers to remove the dust. He put the negative in the enlarger and composed, and then focused the enlarger--by eye. The timer was set for five seconds-- permanently. He closed the lens down and when he "got the right amount of light," exposed for five seconds.

He exposed about 10 different negatives that way putting the paper into a drawer. On some of the prints he would dodge or burn. Then he took the ten exposed prints to the sink and put them all together into the developer. He had a quart container of straight developer in a larger container with steaming water running into it to keep the developer hot. As he shuffled through the prints he would swab hot developer on those areas that were "not coming up fast enough."

He used a stick with a sponge tied to the end of it. Some of the prints got as little as 30 seconds of development, and some got well over three minutes, but I'm not sure of the time. There was no timer. The ones that wouldn't develop were rolled up and dipped into the hot straight developer. That did it. A girl came in and took the prints out of the fixer one by one swabbing with cotton those areas she considered too dark, On the cotton was potassium ferricyanide which is a bleach. The negatives were those of a well known photo-journalist who would let no one but this man print for him. The prints were among the first I had seen that were worse than mine.

I tried other things. I bought an enlarging meter with a computer brain for $150.00. The prints it produced were unsatisfactory. The major problem was that my negatives were poor, but all my proofs were exposed and developed haphazardly so I never knew the truth about my negatives.

I couldn't even find a good book on printing. They said "dodge the shadows" and "burn the highlights." By luck I stumbled on to "The Print" by Ansel Adams and with it to guide me I got started in the right direction. Then I was fortunate enough to be accepted as a student by Ansel at his Yosemite workshop* where I learned the Zone system. When I returned from Yosemite, I knew how a print should look.

If you have followed directions and completed the three basic tests you are now ready to make

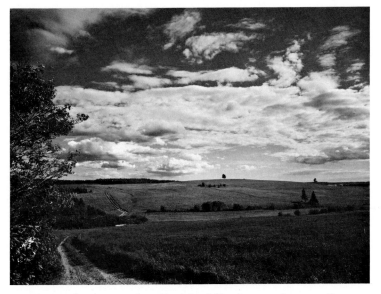

Nova Scotia landscape described in following section — refinements exaggerated for illustration purposes.

*If you are involved in photography and there is room for you at the Yosemite workshop--go. Write to Ansel Adams, Route 1, Box 181, Carmel, California 93921. Assisting Ansel are some outstanding creative photographers including Liliane DeCock, Richard Garrod, Henry Gilpin, Al Webber, Milton Halberstadt, Perkle Jones, and Dorr Bothwell. Brett Weston and Wynne Bullock usually arrive for a day or two. The people attending are a diverse group in age, occupation, background and ability, but they are bound together by a common love for the medium.

THE FINE PRINT

Before making a print, let me remind you again that you must first make the proper proof in order to select the negative for printing.

Please do not short cut this step. An outstanding print is always the product of an outstanding negative. No one can positively translate negative densities - as seen on a viewing table - into emotional values. You must see the way it prints. The proper proof identifies the qualities of the negative.

I have two negatives of a lovely Novia Scotia landscape under a magnificent sky. They differ only in that one was made with a K2 filter and the other with a G filter. The filter factors applied were 2 (1 stop) for the K2 and 3 (1-2/3 stop) for the G. Both factors are manufacturer's recommendations which worked well for me in Nova Scotia. The negatives appear identical when viewed side by side, but the proper proof shows that one negative captured the lovely soft eloquence of the evening scene, the feeling of light and substance, while the other is just pretty. The negatives even appear to match in contrast and density on the contact sheet. My best efforts in printing both negatives result in echoes of the way they look on the proof. One negative has it, the other has not. The proper proof always shows which negative to print.

First, the negative must be dust free. Hold it under a strong light parallel to the light beam and tilt it back and forth until you see the specks of dust. Some photographers hold it under the enlarger light. If you don't see dust, it's because you aren't holding the negative in the proper position. There is dust. Brush it off with a static eliminator brush. With the Kodak electric brush the dust almost falls off. Brush both sides and get every speck or you'll spend ten times as long spotting the print later. Place the negative in the carrier, emulsion (dull) side down. Next, raise or lower the enlarger head to get the desired print size.

A spare print is placed on the easel to raise the grain magnifier to the height of the printing paper and you focus sharply on the grain with the lens wide open. Many enlargers have "backlash" so you must check after you let go of the focusing control to see if the grain is still sharp. Lights on and a final look at the proof sheet shows that the contrast used for the proof #2 (normal) seems right for the negative.* We'll start with that paper grade.

THE TEST STRIP

The lens is stopped down to f/11. f/8 to f/11 are generally the best aperture settings for maximum sharpness of enlarger lenses. An 11 x 14 sheet of Varigam is placed on the easel. One of my students was having trouble until we discovered he was using 8 x 10 paper (same brand) to make test strips for 11 x 14 prints and it had a different speed than the 11 x 14. Use the same paper, same size, from the same box and use a full sheet. We want full information.

The timer is set for 3 seconds and the sheet is given a 3-second exposure. Next, cover 2 inches at the right side with a cardboard and expose for three seconds again. Continue, and after the last exposure develop with constant agitation in one quart Dektol to two quarts water. For 2 minutes--exactly, then 20-30 seconds in two quarts of water with 3 oz. of 28% acetic acid. Finally, into the Kodak Fixer. Agitate 30 seconds, turn on the light and look, really look at the high values. Ignore the low tones for now. In this print the highest values are in sections of the clouds. In the print we expose for the high values first. Let's assume that the high values are a bit weak in the 9 second strip and definitely heavy in the 12 second strip. We will try 10 seconds. Set the timer for 10 seconds and expose a full sheet of paper, develop 2 minutes and fix.

This is the pilot print and requires real concentration, first in sections and then all together. Carefully examine the high values first. The clouds look a bit heavy. The foreground meadow has a range from Zone III in shadows to Zone VI where the tips of the grass are brushed by

*Assumes cold light enlarger. Condenser enlargers will print the high values almost two Zones higher than they appear on the contact sheet.

the low evening sun. The small black pine trees at the top of the rise against the sky--aren't black. We want the full range that the paper can deliver. It would be physically impossible to burn in the individual small pine trees without darkening the sky around them.

The reason the clouds at 10 seconds look too dark is a result of the intermittency effect. Ten one-second exposures will give less density to a print (or a negative) than one ten-second exposure. Try it. Our test strip was a group of three second exposures but the print was exposed steadily for 10 seconds. To compensate for the intermittency effect we reset the timer for 9 seconds. That should take care of the clouds, but the trees were weak at 10 seconds. They will be weaker at 9 seconds. What we need is more contrast. With my Codelite head* I dial in more black by turning the "hard" rheostat a bit. With other enlarger heads you must change paper grades or variable contrast filters.

The Kodak Darkroom Dataguide has a dial wheel for determining the different exposure times required when Polycontrast filters are changed. Dupont says their variable contrast filters will all print at the same exposure time, except the hardest (highest contrast) filter which prints at twice the exposure time of the others. My tests for maximum black at minimum exposure time for the various filters did not agree with the manufacturer's suggestions. If you are using these filters**, you will save time and materials by testing each one for minimum time for maximum black. Make up a chart giving each filter a factor. For example if the #2 filter required a 10-second exposure for maximum black, you could give it a factor of 1. If the #3 filter required 13 seconds, its factor would be listed as 1.3, etc.

If you make your pilot print with the #2 paper or filter, and then decide to increase or decrease contrast, apply this factor. My results would not be valid for other enlargers with different characteristics.

Getting back to the print, we have seen that the steady 10 second exposure produced more density than the inter-

*See Catalogue.

**Kodak filters can be used with DuPont papers and vice versa.

mittent test exposures. Even a slight difference in print exposure is noticeable in the delicate high values. We now reset the timer for 9 seconds or whatever the new time would be for the next higher contrast filter or paper grade on other enlargers. If the factors haven't been worked out, a new test strip print at 3 second intervals is made on the new paper grade or with the new filter.

Make the next exposure--9 seconds with higher contrast and process as before. In the fixer the print now looks generally fine. The clouds have higher value and more luminosity than in the first print due to the shorter (by 1 second) exposure. At the lower end of the scale, the pine trees are maximum black due to the harder paper and in spite of the shortened exposure. There is no discernible change in the mixed values of the foreground. The midtones react much less than the highest and lowest values to moderate changes in contrast grades. We have the pilot print. Density and contrast are satisfactory.

Expressive Refinements

Are there creative controls possible that will enhance the expressive intent of the print? This is the time to place the print on the bottom of an overturned tray, stand it up under a good light and step back about 4 feet. (Less for an 8 x 10.) Looking, really looking, at the whole print reveals several possibilities. All of the edges appear a bit weak and the corners even weaker. This happens with many prints for several reasons. Flare in the camera during the exposure results in greater density at the edges of the negative. This effect occurs in varying degrees in all cameras. A contact print of a photograph of an evenly lit card will show the denser edges camera flare produces. With my Sinar 4 x 5 the effect is less with the loose bag bellows than with the normal accordian type bellows. I suppose that is because the reflecting surface of the bag is farther away from the edges of the film. Some cameras have less effective internal baffling than others.

Further weakening of the values at the edges of the print occurs during enlarging because the light travels farther from the lens to reach the outer edges of the paper. The falloff is greater with condenser enlargers than with cold light heads. A light meter placed in the center of the enlarger light pattern on the easel (no negative in the

carrier) will show quite a different result at the edge of the easel. The effect is greater (worse) with a negative that is the maximum size that a condenser enlarger will handle because the condensers are usually designed to just barely cover the negative.

An enlarging lens designed for the next larger format than the negative being printed will be helpful. For instance, a 75 or 80 mm. lens will cover a 35 mm. negative far better than the conventional 50 mm. lens and will produce more even light across the easel. The prints will be noticeably sharper (assuming lenses of equal quality), especially at the edges.

We may need more exposure at the edges of our print for yet another reason. If the print is to be presented on a white mount, there will be flare from the mount that will further weaken the edges.

In addition to strengthening the edges, what other controls might enhance the emotional impact of this print? In the field you will notice that the landscape seems to increase in value (get lighter) in the distance. I don't know how much of this effect is psychological (you can see near objects, textures, etc. better than distant ones) and how much is physical. The physical effect is caused by minute particles of matter or moisture in the air. This effect which exists in nature appears in our unmanipulated (straight) print, but the illusion of presence in many photographs of this type can often be augmented by slight deepening of foreground values tapering smoothly off to a paler (and emotionally more distant) horizon. It can give this print a stronger feeling of space and depth.

The additional foreground exposure is determined by a reinspection of our original test strip print. The 12 second exposure looks good for the near foreground so we will add about 3 seconds to our 9 second basic exposure. The basic exposure time and paper grade have been determined; 9 seconds, #3 contrast paper. We will make our basic exposure and add the refinements.

Lights out, open the lens and refocus the negative sharply on the grain if you are using an incandescent light source. If you are using a variable contrast filter below

the lens, leave it in place while you focus.* The reason for refocusing is that the negative often buckles from the heat of an incandescent lamp. (See Sharp Prints in next section).

Since the next step requires controlled dexterity, it pays to make a dry run--a dress rehearsal with no paper on the easel. White room lights are turned off and the basic 9 second exposure is given. Next, the foreground exposure is added by holding a card beneath the lens. I use the black bottom of the 8 x 10 box that the paper comes in. Irregular saw teeth are cut in along one edge to prevent a hard line appearing on the print. Hold the card with both hands at its outer edges under the lens so that no light can strike the easel. Activate the timer (it is still set for 9 seconds). Move the card smoothly away from you. You can watch the image on the card or on the easel. When the light from the enlarger has been allowed to reach the horizon, immediately sweep the card smoothly back toward you to cover the whole print.

Now practice it again and this time count--one thousand one, etc. as you "burn in" the foreground for three seconds. The edge burning can be done with the same card. We already have completed the bottom (foreground) edge. With the card under the lens, start the timer again. Move the card toward you exposing about three inches of sky and then smoothly back. This must be very subtle--we only want to balance the print and this negative requires just a little edge burning. Two seconds to come down and get back. The same for the right and left. The burning of 2 seconds for the edges has resulted in 4 seconds for the top corners. That works well on many prints including this one and tends to intensify the composition. If we find after performing the dry run that the burning requires more time for good control, we can close down the lens one stop (from f/11 to f/16) and reset the timer from 9 to 18 seconds. That will allow twice as much time to work in.

With everything under control, we make the print as in the dress rehearsal, develop 2 minutes, stop bath and fix. Wait a full minute while agitating the print in the fixer before turning on the white light.

*If you have trouble focusing due to the reduced light through the higher contrast filters, use the #1 filter to focus, then replace it with the proper filter.

The light you turn on is important. All papers dry down in varying degree and reduced values and contrast result. How much to allow for this problem is largely a matter of experience, but it helps me to view the print under a rather weak light. I use a 40 watt bulb in a bullet reflector about 3-1/2 feet above the fixer tray. When the print is finally displayed under stronger light, the tones that it has dried down to generally match closely the more brilliant wet print under the weak light. This weak light is turned on first to get the overall effect of exposure and contrast and then a strong reflector flood is added for more careful examination.

Just as the print was previsualized when the negative was exposed, the scene can be post visualized from a fine print.

The print is in the fixer. It stays there with occasional agitation for five minutes at which time it is placed in the last tray for storage. The last tray is under slowly running water if available. If your facilities do not provide running water, the tray should be dumped and refilled with fresh water after each four or five prints are added in order to prevent the buildup of fixer. Use as large a tray as possible--16 x ·20 if you can. Even with running water, I empty the tray and rearrange the prints occasionally.

In order to save time in the future, it makes sense to write a description of the procedures used in making the print. For 35 mm and roll film a notebook can be kept-- sample pages are at the back of this book. For sheet film I write the printing instructions on the negative jacket. For this print I would write:

Mag 9 (enlarger head marking—magnification)
f/11, 9 sec.
Soft 40 (Codelite settings--you might write--
 contrast 3, etc.)
Hard 46 " " "
+3 (sec.) foreground up
+2 (sec.) all edges in
VGTW (Varigam brilliant white glossy-paper)
2 min Dektol 1-2

This notation takes only a moment and has an auxilliary value. It sometimes happens that a print will be finished,

mounted, perhaps even framed, and suddenly or gradually you realize that it could be improved. If you decide it should be deeper in tone, lighter, more or less contrast, etc. you can see from your notes how the print was made. Knowing the starting point makes refinement simple.

NOTE: In an effort to be concise, I have described the making of a print from a specific negative. (See illustration page 43). To assume that the procedures and materials employed would be correct in all cases would be an error.

The photographer's job is to produce a print that communicates his feeling for the subject. Various papers, developers, dilutions of developers, developing times, etc. all can effect great differences in the atmosphere of any print. The making of a fine print is always a matter of trial and error and the photographer desiring to produce outstanding prints must experiment constantly. The very best printers will often spend a day or more to make a print that satisfies them, while the next negative may produce the desired result on the third sheet of paper.

After the printing session, the prints are placed in the washer unless you wish to proceed to:

TONING

Most photographic papers are of an olive black tone that I find unattractive. You may have wondered how the rich blacks and the subtle suggestion of overall cool purple have been accomplished in some fine prints. The prints were probably toned. In addition to changing the color of the print, slight selenium toning adds brilliance and a rather mysterious enhancement of depth and presence.

After dumping and rinsing the developer tray, pour the stop bath into it for a moment, and then wash out all the trays. Place the water tray with the prints at the left side of the sink. The next tray to its right contains a plain hypo solution made by adding a one pound box of Kodak-- or other--Sodium Thiosulfate to 1/2 gallon of water. The next tray contains 1/2 gallon of water to which is added 1-1/2 oz. Heico Perma Wash and 6 ounces of Kodak Rapid Selenium Toner.* If you wish to use Kodak Hypo Clearing

*This is about a 1-11 dilution of the Toner. Kodak's suggestion of a 1-3 dilution will result in a much more obvious change in color.

Agent instead of Perma Wash, make up the solution in accordance with directions on the box and then add the 6 oz. of Toner. The last tray is running water.

Place six or eight 8 x 10's or four 11 x 14's in the hypo tray. Agitate for 4 minutes, lifting out the bottom print and placing it on top of the stack, turning them over as you go. When the 4 minutes is up, set the timer for five minutes and transfer the prints directly into the toner tray.* Agitate as in the hypo.

Make sure you have a good light over the tray. After about 2 minutes you will see a slight change in print color toward a cooler, more purplish hue. It is helpful to have untoned matching prints in the first water tray for comparison. Soon, the untoned prints will look obviously greenish when compared with the prints in the toner. The prints in the toner will seem more brilliant with richer blacks and "cleaner" high values. The toned prints look sharper and seem to have a greater feeling of depth. When a print looks right, place it in the running water tray. Most prints tone nicely in 3-6 minutes.

It seems that prints with a large percentage of middle grays (Zones III to VI) achieve the right appearance faster than those with large areas of very high and very low values. Set the timer just for general reference and not to tone for exactly five minutes. Unless you are ready to tone all of your prints in the future, I advise you not to start toning. You just won't be able to accept an untoned print when you see the difference.

Different papers react in different ways to the toning process. Kodabromide #2 will hardly tone at all while #3 and #4 tone nicely. I've tried Kodabromide, Velour Black, Brovira, Ilfabrome, Varilour, Polycontrast, and others, but settled on DuPont Varigam some time ago. I like the subtleties that can be achieved with its variable contrast feature and the fact that I don't need 12 boxes of paper on hand (3 sizes in 4 contrast grades). Some of these invariably die of old age before they can be used. Varigam tones well and has a brilliant but not too hard-shiny surface texture when dried on screens. The finish I use is described as "Brilliant White Glossy" and the designation of the double weight paper is VGTW. Other surfaces and tints are available.

*If you rinse between hypo and toner, you may get stains.

WASHING PRINTS

After the prints are toned they must be washed properly for permanence. If the prints have not been toned, they should be put through a Perma Wash bath with agitation for 5 minutes. For greater permanence of untoned prints, some printmakers use a second fresh fixing bath for three to five minutes before the Perma Wash. The second bath will certainly assure the print a longer life, but is not as good an assurance of permanence as the hypo and toner-Perma Wash combination. Information concerning print permanence is contained in "The Print" by Ansel Adams. Another sound reference is the booklet published by the East Street Gallery in Grinel, Iowa.

Residual chemical deposits in the absorbent print paper are difficult to remove. What is needed is constant movement to separate the prints and changes of water to remove harmful chemicals. A good job can be done washing in trays, but only if the prints are frequently separated and agitated by lifting out, and turning over, and the tray is occasionally dumped and refilled.

David Vestal suggests a procedure that seems workable, but tedious.

"A flow rate sufficient to change the water in the tray completely every 5 minutes is the minimum effective rate. In washing as in other processes, hand agitation is essential. Just leaving the prints in the tray, as Ansel Adams says, 'is to invite disaster.' I flip the prints in the wash just as in the other trays, with this refinement. Starting with the six prints face up, I move them up face down, and then flip again until they are again all face up. Then I bring the next print up and place it face up on top, and pour all the water out of the tray, holding the prints so they don't get dumped out. This way a different print is on the top of the stack after each change of water, and all the prints get equal washing. Otherwise the top and the bottom prints would be washed long before the ones in the middle layers. This 'flip-&-dump' cycle should be done at least every 5 minutes. The more nearly constant the movement of prints is, the faster and more effective your wash will be."*

*East Street Gallery Booklet, p. 10.

The total time for the above procedure is not specified and I would hesitate to hazard a guess.

I use the following procedure. My prints are washed in a water-driven rotating drum washer and I have had no problems from stains, etc. The drum washer separates the prints by constantly sliding them under and over one another and changes the water continuously. The most recent research indicates that a rapid exchange of water is not as necessary as was generally believed, possibly because of the extreme dilution of the small volume of chemicals in a comparatively large volume of water.

Testing for harmful residual chemicals

Because of the variables inherent in washer efficiency, procedures, and local water chemistry, it is important to test for thorough washing.

You can make a test by mixing an HT-2 solution (or see catalogue).

Distilled water--about 10 oz.--375.0 cc
Acetic Acid (28%) 2 oz.-- 62.5 cc
Silver Nitrate 1/8 oz.-- 3.75 grams
Distilled water to make 16 oz. total

The test is made by adding an unexposed but normally processed sheet of paper to the prints being washed. After washing about 1/2 hour, remove the white sheet and wipe it off. With an eye dropper, place a drop of HT-2 at the center and another drop near the margin. In exactly two minutes, wipe off the solution and immediately compare the resulting stains with the stain chart in the Kodak Darkroom Dataguide. The stain will continue to darken, so it is important to be ready for comparison at the two minute mark. If the stain is unacceptable, cut out the stained areas and return the print to the washer for a re-test to be made 1/2 hour later.

My test using the HT-2 formula showed on an unexposed but developed, fixed, toned "print" a stain much lighter both at the edge and in the center of the print than the lightest stain shown in the Kodak Darkroom Dataguide. The test was made after a half hour wash with 16 double weight prints (8 x 10) in the drum washer. Prints were

rinsed off before being placed in the washer and the water input was at the rate of a bit less than two gallons per minute. (It took a 1/2 gallon graduate 18 seconds to fill from the overflow pipe).

Although my tests look fine in 1/2 hour, I wash for one hour using a garden hose timer (available in hardware stores) which shuts off the water at a predetermined time. It does no harm to leave washed prints in the drum overnight if the water temperature stays below 75°.

DRYING

Heated drum dryers are being used less nowadays for several reasons. Many object to the slick shiny surface they impart to the print, the care the drums require to assure pock-free ferrotyping, the high initial cost and space requirements, etc. I have found the use of the plastic insect screens available in hardware stores to be a superior method of drying prints.

Place a print face up on a clean overturned tray on to which a stream of water is running. Swab the face, turn it over, and swab the back with a clean sponge. This final rinse will remove any particles of grit that might have gotten through the water system. When all the prints are on the tray, stand the tray on end to drain. When drained, the prints are sponged off one by one and placed face down on the plastic screen. The screen is cheap, rustproof, clean and fast. You don't have to feed prints into it one by one or wait to catch or free stuck-on ones on the way out. You can make screens up on wooden frames which can be hinged and folded against the wall when not in use, or have a screen man make them up on aluminum frames. You will have plenty of space for drying by arranging them as slide-out drawers about three inches apart. Take them out and hose them off from time to time. A 28'' width is comfortable to work with as you can reach the back of it. It will hold three 8 x 10 prints per running foot and will take a row of 11 x 14's horizontally and another row vertically without waste of space. The prints will dry in 2 to 4 hours depending on humidity conditions of the day.

FLATTENING PRINTS

If prints are not to be mounted, they should be flattened and then trimmed for a finished appearance. After drying on screens, I insert the prints into a rotary dryer with the back of the print in contact with the drum. Prints curl toward the emulsion side, but about a minute of heat in the dryer counteracts this tendancy. This works better than flattening in a dry mount press because the round drum bends the print away from the direction of curl. Small dryers can often be found at reasonable prices. Since the prints are not ferrotyped, the drum finish condition is of no importance. If you do find a used dryer, it is a good idea to replace the apron which is probably contaminated from insufficiently washed prints.

A very nice presentation of an unmounted print can be prepared by dry mounting it back to back to a fixed and washed sheet of the same paper that was used to make the print. This adds body and the print will stay flat as the opposing papers counteract each others curling tendancy. Trim after mounting.

MOUNTING

A fine print deserves a fine presentation. Nothing looks more amateurish than a wrinkled print with white borders. The most sophisticated piece of equipment in Edward Weston's minimally equipped darkroom is reputed to have been a dry mounting press. Perhaps a good smooth mounting job can be accomplished with a hand iron, but frankly I've never seen it done. A good press is expensive, so often two or more photographers share one.

Preheat the press to 250°. Insert the untrimmed print between two mounting boards and close the press. After about 20 seconds, remove the flattened print and place it face down on an extra mounting board. Brush off the back of the print with a foxtail draftsman's brush. Take a sheet of dry mount tissue (high temperature Seal or Kodak) and place it on the print. Hold the dry mount paper down and place the tacking iron at the center; draw the iron smoothly to the edge of the print. Use the amount of pressure you would use to write through several carbons. The path is

from the center of the print to the center of one of the edges. Stop before reaching the very edge or you will drag the dry mount residue on to the scrap mounting board and it will get on the face of the next print. Turn the print 45° and repeat. The tacking must go from the center out to the center of each edge--not to the corners. Don't try to save time by making the cross in two movements--from edge to edge. You will wrinkle the tissue and ruin the print. Now trim the print to final dimension. I use the Nikor wheel trimmer. Its self-sharpening wheel cutter gives a slick edge without breaking the emulsion as most guillotine trimmers do. Hold the print down hard close to the edge being trimmed with a piece of plastic or cardboard so that it can't creep as you trim with a quick, strong, bear-down motion. A strip of 1" masking tape adjacent to the cutting edge is helpful in keeping the print from slipping.

Next step is to mount the print on the board. The board I use is Bainbridge Hot Press cut 14 x 18. Some photographers believe that each mount should be proportioned to the print size and shape, but a variety of shapes creates problems of storage and display. 11 x 14 prints look a bit crowded to me on a 14 x 18 mount, so I generally make my larger prints closer to 10 x 13. 8 x 10 prints look luxurious on 14 x 18 boards. To digress, my feeling, and it is completely a personal matter, is that generally big scenes, powerful landscapes, industrial, and architectural subjects look very fine when printed large (11 x 14 or larger). Portrait heads, small forms in nature and more delicate subject matter may look somewhat gross in prints over 8 x 10. I have a lovely portrait by Brett Weston which is a contact print from a 4 x 5 negative. It is elegant and jewel-like and I wouldn't want it bigger.

Positioning the Print

When mounting, the object is to get the print tacked square on the board and exactly equidistant from the sides. Usually a bit more space is left at the bottom than at the top. Nothing is more infuriating than getting it on crooked and nothing is more tedious than getting it on straight. I have made up a device* that takes any board up to 21" wide by any height. The board is automatically centered and

*See ''Dry Mount Jig'' in Catalogue section.

Shore detail, Rhode Island. Sunlit brown sand was placed on Zone V.
The sand at a more reflective angle (above top of rock) fell on about
Zone VII. The specular reflections are direct reflections of the sun,
and appear as pure white in the print. The near axis light created a
thin shadow line between the rock and sand which helped separate
the quite similar values.

Wassaic, New York. The viewing filter showed a merger between the sky and the right side of the tower so a "G" (orange) filter was used. Pure white appears in small areas of the distant grainery; total black in the power lines and windows.

Exposure was timed, in rapidly changing storm light, to record the grainery brilliantly against the dark sky.

Shore detail, Rhode Island. Sunlit brown sand was placed on Zone V.
The sand at a more reflective angle (above top of rock) fell on about
Zone VII. The specular reflections are direct reflections of the sun,
and appear as pure white in the print. The near axis light created a
thin shadow line between the rock and sand which helped separate
the quite similar values.

from the center of the print to the center of one of the edges. Stop before reaching the very edge or you will drag the dry mount residue on to the scrap mounting board and it will get on the face of the next print. Turn the print 45° and repeat. The tacking must go from the center out to the center of each edge--not to the corners. Don't try to save time by making the cross in two movements--from edge to edge. You will wrinkle the tissue and ruin the print. Now trim the print to final dimension. I use the Nikor wheel trimmer. Its self-sharpening wheel cutter gives a slick edge without breaking the emulsion as most guillotine trimmers do. Hold the print down hard close to the edge being trimmed with a piece of plastic or cardboard so that it can't creep as you trim with a quick, strong, bear-down motion. A strip of 1" masking tape adjacent to the cutting edge is helpful in keeping the print from slipping.

Next step is to mount the print on the board. The board I use is Bainbridge Hot Press cut 14 x 18. Some photographers believe that each mount should be proportioned to the print size and shape, but a variety of shapes creates problems of storage and display. 11 x 14 prints look a bit crowded to me on a 14 x 18 mount, so I generally make my larger prints closer to 10 x 13. 8 x 10 prints look luxurious on 14 x 18 boards. To digress, my feeling, and it is completely a personal matter, is that generally big scenes, powerful landscapes, industrial, and architectural subjects look very fine when printed large (11 x 14 or larger). Portrait heads, small forms in nature and more delicate subject matter may look somewhat gross in prints over 8 x 10. I have a lovely portrait by Brett Weston which is a contact print from a 4 x 5 negative. It is elegant and jewel-like and I wouldn't want it bigger.

Positioning the Print

When mounting, the object is to get the print tacked square on the board and exactly equidistant from the sides. Usually a bit more space is left at the bottom than at the top. Nothing is more infuriating than getting it on crooked and nothing is more tedious than getting it on straight. I have made up a device* that takes any board up to 21" wide by any height. The board is automatically centered and

*See "Dry Mount Jig" in Catalogue section.

squared as is the print which can be any size from 4 x 5 to 16 x 20. With it you can place and tack a print perfectly in 30 seconds.

Some boards should be heated in the press before mounting or they will take a set (bend) that weights won't flatten. The Bainbridge works the other way and I don't heat it. My prints come out of the press really flat and stay that way. You will have to try both ways if you use some other kind of mount board. Heating the board is not necessary before mounting to "drive out the moisture." Moisture can't get through the mounting tissue and in any case moisture would come out of the edges of the board.

Dust off the mount and the back of the print and position the print to your taste. About 1/2" more mount showing at the bottom than at the top is often pleasing. Place a weight in the center of the print to hold it. Carefully lifting each corner, slip in the tacking iron and tack the tissue to the board. Stay away from the very edge of the tissue or you will smear it on to the board outside the print area. Brush the print face and the "covering board" (an extra mount board used between the steel face of the press and the print) and put the print into the press. Close the press and remove the print in about 45 seconds.

Sign your name with fine black ball point or pencil close under the lower right hand corner of the print.

Searsport, Maine. The highest value (door on left) was placed on Zone VIII. This placement would have been too high if the church was of smooth finish, but the thin shadow line of the clapboard gives a feeling of texture. The viewing filter showed the clear north sky would record as shown without a filter, so none was employed. Camera position was carefully chosen to preserve the perfect symmetry of the structure.

Taos Pueblo, New Mexico. Shadowed area was placed on Zone V and the sunlit foreground fell on Zone VI. This unusually small difference occurred because structures just behind the camera position reflected light into the shadows. The backlight placed the near side of the dogs in shadow and the black dog is total black in the print. The white dog provides the only pure white where the backlight rims the top of his body.

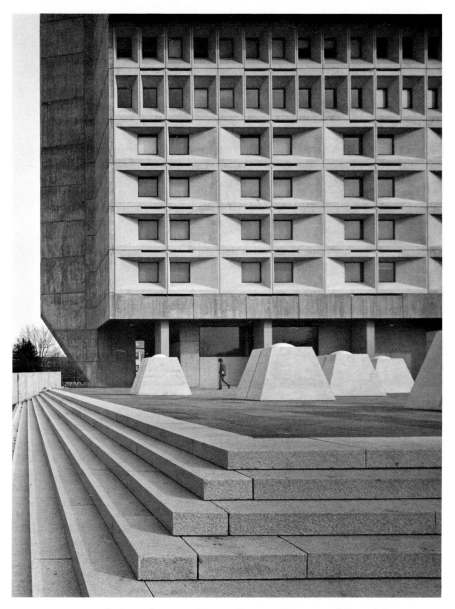

University of Massachusetts Campus Center: *Courtesy of Marcel Breuer and Herbert Beckhard, architects.*

Photographed in weak sunlight. Stronger illumination would have complicated the intricate window detailing. The important values of the building spanned three Zones and were arranged on Zones V, VI, and VII. Black appears in the cracks between the foreground steps and openings beneath window frames; white in the sky at the horizon and the skylight domes on the plaza.

Extreme view camera controls were employed to preserve the geometric linearity of the design. After leveling the camera, it was swung to the left so that the back was horizontally parallel to the face of the building. The lens was then slid to the right and raised, the back slid to the left and lowered. The lens was then tilted forward so that sharp focus was achieved at the top of the shaded windows and the near foreground. A small lens stop -f/64 was used to sharply record the distant trees.

Beach near Lunenberg, Nova Scotia. The late evening sun is directly behind the camera, (axis light). The dark water was placed on Zone IV, the light rocks fell on VI. A #12 medium yellow filter reduced the blue water to Zone III print value without affecting the rocks or the white water. Several exposures were made to insure the best compositional arrangement of the breaking waves.

Barns Near Paterson, New York. Placement was determined by several readings. There was seen to be about a three Zone difference between the highest value requiring texture (the right hand barn) and its roof. That roof was placed on Zone V, the barn siding under it fell on Zone VII. Other sunlit areas fell on VI and VII. Viewing filter revealed a merger between top of the left hand silo and sky, so a "G" filter was used to darken the sky tones. Maximum black appears in unlit opening at top of left hand silo, etc. The specular reflection of the center silo prints pure white while the other silo reflections retain some tone.

Portrait of the Artist, Dorr Bothwell, at Yosemite. Flesh tones placed on Zone VI. The exposure required to properly record the shaded flesh tones was too great to permit detail in the sunlit rock. Printing down the rock does not add texture. The reflection from the rock was so strong that it added an attractive rim light to the right side of the face. The fact that the reflection caused no flare is a credit to the camera baffling and lens coating — Nikon F, 105 mm. lens.

ENLARGER CHARACTERISTICS

Recently a student brought me a print, proof, and negative of a mountain stream in sun and shade. He had made the print on the softest paper grade, but a foreground rock in sun was blocked and showed a textureless gray and the white water had the same plaster-like quality. The low values were unnaturally dark and there was no luminosity in the shadows. The print suggested overexposure and/or overdevelopment of the negative, but his proper proof looked fine, as did the negative.

We made a straight print using my enlarger and easily achieved a fine result with #2 (normal) paper. The foreground rock in sun and the sunlit water were brilliant and full of delicate textures, the shadows were luminous and the lower values showed rich detail where empty black appeared in his print. He was shocked and said that if he had not seen it done he wouldn't have believed it. I wasn't surprised since his experience was typical.

The reason for the difference in print quality (see illustrations) was solely due to the type of printing illumination. His enlarger is a new 4 x 5 model with a condenser head. My enlarger has a cold light head.

Through experience, I know that it is difficult to convince people of the superiority of cold light without a demonstration. Logically, it doesn't make sense that manufacturers don't supply this light source if it really produces such dramatic improvement in print quality.

The situation might be likened to music reproduction equipment of a few years ago. High priced phonographs were manufactured widely that could reproduce only a small range of tones. Nothing better was available for comparison and most people couldn't tell the difference. Musicians could. They had studio equipment modified for their use that could reproduce the full orchestral range. Demand grew and small companies built sophisticated High Fidelity sound equipment for the home. The big commercial companies had to follow because the public suddenly knew the difference.

Lost River, New Hampshire

Cold light print shows rich tones throughout and fine gradation in the
highest value — white water.

Photograph and prints courtesy of Ken Lee

Condenser print is harsh and the white water is completely blocked.
Both prints exposed for black film edge.

Cold light is high fidelity. Enlargements duplicate the contact print in tonal progression, separation, and range. All of the very good printers I know use cold light.

According to the English magazine, "Creative Camera," Ansel Adams is "perhaps the world's best printer." Ansel says, "I do not use the conventional condenser type enlargers..... They distort the diffuse-density range of the negative (favoring 'soot and chalk' print qualities) and also increase grain and the evidence of defects."*

Sooner or later more photographers will see the dramatic difference and condenser light sources will go the way of the ancient record players.

Andre Callier first observed the effect of collimated (beamed) light on the higher negative densities. He found that the higher densities scatter beamed light much more than do the lower negative densities. The proof of this may be seen when a contact print** of a negative is compared to an enlargement of the same negative made with a condenser enlarger. The contact print will have a far smoother, richer look. If you print with a condenser, compare an enlargement with a contact print of the same negative.

The loss in detail of the lower values in my student's print occurred because he increased the printing exposure past the time required to get the film edge black. This was done in an attempt to get some detail into the higher values. With this additional time, however, he overexposed (printed through) the delicate lower values.

The student then tried a sheet of diffusion glass in the filter drawer, but when the glass was placed close enough to the negative to be effective, it came into focus and an all-over grainy pattern and long exposure times resulted. Next he tried diffusion paper, but it buckled from the heat. The lamp (bulb) was frosted so there was nothing to do in that area. As a last resort he sprayed the inside of the

*Hasselblad Magazine #4, 1971, p. 23.

** Contact prints are perfect reproductions of actual negative densities regardless of the light source used. (A contact print made under a condenser enlarger is identical to a contact print made under a cold light enlarger or a household bulb, etc.)

lamp house with reflective heat resistant white paint in an attempt to spread the light source. There was no appreciable difference.

The contrast range of that negative was too great for his enlarger so he tried increased exposure and reduced negative development time with some improvement. He had used my developing time since his enlarger had not arrived in time for him to make tests for it. With the new shortened time the negatives printed closer to the higher Zones visualized but the progression of values was compacted by the shortened development time and the prints were flat and lacked separation in the lower tones.

He gave up the fight and at my suggestion he bought an inexpensive (under $100.00) cold light head for his Beseler enlarger. It solved all of his problems and he is making very fine prints. The student's name is Ken Lee of 209 Mamaroneck Road, Scarsdale, N.Y. He has kindly agreed to verify all of the above. Since the light is cold, negatives don't buckle, the light is more even in intensity over the easel, and grain, dust, and negative defects are greatly reduced. Though you might have heard the opposite, there is no loss of sharpness; 35 mm. Tri-X HC110 negatives produce nearly grainless prints to 11 x 14 with beautiful tonal gradation and they are sharp.

The cold light head that Ken purchased is excellent with graded papers and with variable contrast papers when used with filters.

Many photographers are aware of the Callier effect, but believe that it results only in a negligible increase of contrast. In order to determine the actual extent of the Callier effect, I devised the following test.

Eight frames of 35 mm. Tri-X were exposed at Zones I through VIII and given normal developing time of five minutes in HC110. A proper proof showed all Zones reproduced as placed. The print from the Zone V negative matched the Kodak gray card and the Zone VIII print had the correct slight tonality.

Enlargements of each negative made with the cold light timed for minimum exposure for maximum black through clear film edge matched the proper proof.

Enlargements made with the condenser head timed for maximum black showed no tonality for Zone VIII, although prints below Zone V matched the cold light prints. Out of curiosity, I made a test strip with condenser of the Zone VIII negative and finally got a Zone VIII print value at more than twice the time required to get maximum black. This doubled printing exposure printed the Zone V and other negatives much too dark, of course. The negatives obviously were overdeveloped for the condenser enlarger-- too dense in the high values.

I exposed three more rolls of film to all Zones and developed them for progressively shorter times to reduce the contrast range. The roll developed for three minutes produced a print of the proper Zone VIII value, but the short development time resulted in reduced densities and a lack of separation for the lower zones. Nevertheless, I think that negatives developed for condenser enlargement should be based on correct Zone VIII density since lost shadow detail is less disagreeable than blocked high values.

All test prints were made on #2 Graded paper rather than variable contrast so that any possible difference in light color from the two light sources would have no effect on print contrast.

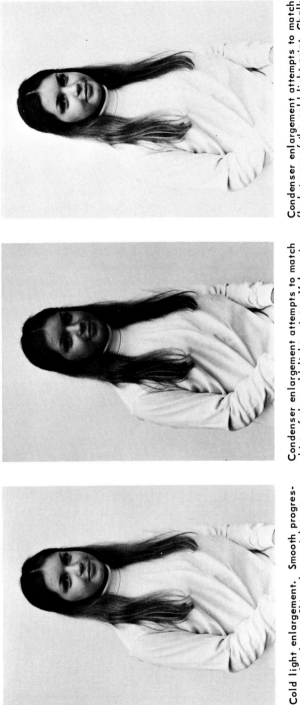

Cold light enlargement. Smooth progression of values. Shirt shows rich texture and is well separated from the background. Flesh tones reflect mood of the soft lighting.

Condenser enlargement attempts to match shirt of the cold light print. Values in shirt break abruptly, overall flesh tones are much too dark, though the soft cheekbone highlight is as high in value as in the cold light print. Hair is "soot".

Condenser enlargement attempts to match flesh tones of the cold light print. Chalk like flesh tones break abruptly from highlights to shadows and do not give the feeling of the soft open shade illumination. The shirt is without texture and does not separate from the background which prints almost pure white.

All prints are unmanipulated. They were made on normal graded paper. Differences would be more dramatic under more usual (sunlight and shadow) illumination. Negative is normal as shown in contract strip illustrating exposure. (see "Exposure" section)

The condenser effect is readily observed in prints from negatives exposed on gray days. There seems to be sunshine, but there are no shadows!

When a portrait of a subject wearing white clothing requires an exposure for the clothing that renders the flesh tones too dark, (though everything looks fine in the contact print), the Callier effect is in operation. (See illustration.)

There is also a variable contrast cold light head that is the most sophisticated light source for black and white printing that I know of. I first saw this equipment in Ansel Adams' darkroom. His Beseler 4 x 5 enlarger had a variable contrast cold light head installed.* In the head were three separate light grids. There was a continuously variable rheostat control for its hard (bluish) light grid and another for its soft (green) light grid. The third grid was on a switch and was for high speed use on graded paper in conjunction with the hard light grid. With it he could

1. Set infinite contrast grades from 0 to 4 with no change in exposure time.
2. Achieve any fractional contrast grade.
3. Simply ''pour in'' a little more or less hard or soft light to affect either the high or low values separately.
4. Print part of the negative with a different contrast.

I purchased this same equipment. I find that its creative capabilities are limited only by the imagination of the user. This head is available for most 4 x 5 enlargers. The cost is admittedly high, but if you desire perfection, this machine is the answer.

Both of these heads are listed in the catalogue section.

There are many possibilities of procedure with the variable contrast head. I set both rheostats for #2 if the contrast looks right on the proof sheet. (The proof sheet is always made with #2 setting.)

*See illustration of equipment in Camera and Lens by Ansel Adams.

After making a test strip and then pilot print, I examine the high values for tonal value. I might then "pour in" a little more black if the low values are weak, or reduce the black if too strong. Sometimes I give a print 12 seconds with the #2, then turn off the hard light and enrich a foreground area (or a sky) with perhaps 6 seconds of the soft only.

It is easy to exaggerate the contrast between a light rock and the surrounding dark water while retaining the smooth tone within the rock. The procedure might be an overall exposure with #2 setting. A subsequent exposure with #4 setting is made while dodging the rock. The result is that smooth tones are retained in the rock while the hard light applied to the water darkens and increases the separation (contrast) of the delicate low values within the water.

SHARP PRINTS

Getting the best possible resolution depends on several factors:

1. Sharp focus is assured with an aerial image grain magnifier. If the grain is sharp, the image will be sharp. Focus with the lens open, then stop down to f/8, f/11, or f/16 before making the exposure. The grain magnifier will show the best lens opening if you watch as you stop down.

2. The enlarging process always results in some loss of image quality (as compared to the sharpness of a contact print), so it is apparent that the finest lenses available should be used. The Schneider Companons always receive the highest rating in tests that I have seen published and are considered the standard of excellence by most serious printmakers.

3. The enlarger and easel must not move during the time of exposure. This requires good structural design, weight, solid construction, and a strong base (counter) for the enlarger to rest on.

4. The negative carrier, the lens, and the easel must be parallel to each other, front to back and left to right. This can be checked with a level. Start from the easel and

try to level front to back and side to side. The easel doesn't have to be level, although alignment is easier if it is. Move up to the lens and place the level across the lens face. The glass is recessed so you won't scratch it. There are screws, etc., that may be loosened for adjustment if needed. The lens should not be leveled if it was impossible to level the easel. It should be parallel to the easel. The last step is aligning the negative stage with the lens and easel.

There are levels available that may be adjusted to center the bubble regardless of level and they make the alignment job simpler.

5. An enlarging lens of longer than "normal" focal length (discussed previously) will produce sharper results.

6. The most common problem causing the greatest loss of resolution in prints is the negative popping out of focus from the heat of condenser enlargers. The effect is the same as the popping of a color transparency when it is projected.

From an interview with a leading professional printer, Sidney Kaplan, in the May 1972 issue of Camera 35 —

"Q: Since you print with a condenser enlarger, do you have any problem with negatives popping out of focus?

A: For 8x10 prints, put the negative in and put the No-Scratch on, then let the negative pop when the enlarger is hot. After the negative is popped and in focus, you put the red filter in front of the lens and then put the paper in and, in one motion, swing the red filter away and hit the timer.

Q: But with Polycontrast, don't you have problems if you leave that red filter on too long?

A: How long should it take to put a piece of paper in and turn on the timer?"

That seems a good procedure, but tests should be made to determine if there is any fogging effect while the paper is placed on the easel. If there is a problem, the red filter could be covered with tape or cardboard as there is no necessity for seeing the image on the easel once the image is focused and the easel properly placed.

PAPERS

Different printing papers will produce significant differences in the appearance of your prints. There are dozens of brands, finishes, weights, and contrast grades available in most retail camera stores. Make sure to check the expiration date of the paper you choose.

The ideal paper for me is a paper capable of producing the richest blacks and purest whites on moderate contrast grades. The paper would have an unobtrusive (not slick shiny) surface, but would dry to a brilliant finish. It would tone well for all grades, and the various grades would match in terms of image tone.

The test for rich blacks and pure whites takes but a few minutes and often makes other tests unnecessary as you can quickly see that most papers won't fill this first criteria. Subject the papers to be compared to a gross overexposure under the enlarger with one half of each sheet covered by a card. Develop two minutes and fix. Comparison will show the brilliance of the whites and the depth of black that is inherent in the papers. A valid comparison can only be made of papers of equal contrasts and the designations of manufacturers are often at variance. For instance, a #2 Kodabromide is softer than Varigam with a #2 filter; #2 Brovira is equal to #3 Kodabromide. Some European papers are one grade contrastier than our papers at the same designation. The softer grades such as the #2 Kodabromide will not produce a really good black.

The reason that I prefer moderate paper grades is that papers of higher contrast would require a negative of lower contrast. Such a negative is made by reducing development time to reduce the high value densities. Unfortunately, controlling the high values this way also reduces contrast in the lower values. The comparative reduction in low value density and contrast is less severe; but the low values are inherently weak in separation and I feel that further weakening through short negative development is apt to result in muddy low values. Higher contrast paper would also have its greatest effect on the high values in terms of contrast so the needed low value contrast

69

would still not be bolstered sufficiently. The condenser effect of increased contrast applies only to the higher densities and does not add crispness to the lower values. But most moderate contrast graded papers do not produce good blacks.

I have found that I get the best results in terms of brilliant full scale prints when I have a fully developed negative in which the low values are well supported and the high values are controlled by the use of cold light illumination and moderate contrast paper. Varigam will print a rich black regardless of the filter used because the paper has black capability. It will tone uniformly regardless of the grade (filter) used. Graded papers will not tone equally for all grades. Even untoned, most graded papers will not match each other in black or in paper tone (color) for the different grades.

Of the graded papers I have tried, Ilfabrome is outstanding. Rich blacks and very pure whites are evident and the image tone is superb - a trace of cool purple. The surface is rich and brilliant when the glossy finish is dried on screens. If I were limited to graded papers, I would use Ilfabrome. It can be toned for permanence, but selenium toning has no effect on its color. Untoned Ilfabrome (or toned) matches toned Varigam.

I find that Varigam toned is exactly like Ilfabrome in all respects. Two prints from the same negative look as though they were made on the same paper. I prefer Varigam because various parts of the negative can be printed to different contrasts, three boxes is all I have to stock, and all prints match each other in terms of range and tone. Other available variable contrast papers are Varilour which for me dries down excessively and produces muddy low values. Polycontrast has a disagreeable greenish color untoned and produces a two toned effect of greenish and a rather coppery color when toned.

Every photographer with a real interest in outstanding print quality has his own ideas of what a paper should look like, and final choice is certainly a matter of individual taste. The best paper for you is the one that produces the range, tone, and finish that pleases you. Prints from the same negative will show the great differences in emotional impact that the various papers can provide.

SAFELIGHTS

Loss of brilliance through slight fogging of high values is very common. Safelights often imperceptively degrade an exposed print but fail to fog the unexposed white borders since the fogging exposure is not sufficient to break the paper threshold.

A sure test is made by subjecting a sheet of the most sensitive (fastest printing) paper you use to a normal print exposure with a negative in the enlarger and all safelights off. Place the print where the developer tray usually is with a circular developing tank lid, etc. on the print. Turn on the safelights for three minutes, then develop normally, but in the dark. If the print shows a light circle where the lid was, you have fog from safelights or white light leaks in the darkroom. If it shows a dark circle, you have bleach*. Small died glass ruby bulbs bleach Varigam in my darkroom.

Small died amber bulbs recommended for Varigam fog it heavily in my experience.

Several students were getting bleach and thought it was fog because they used a card to partially cover the exposed print and forgot which part of the print was covered.

Kodak bullets with O.C. filters show no fog or bleach even with 25 watt bulbs burning four feet from pre-exposed Varigam for three minutes. Kodak recommends 15 watt bulbs.

Any of the above may be at variance with experiences in other darkrooms or with other materials. Test, to be sure.

*Caused by exposure of some sensitive materials to red light after a white light exposure. It is called the Herschel effect and is thought to be the result of actual decomposition of the latent image by the red light exposure.

TRIPODS

A 4 x 5 negative requires a two times enlargement to produce an 8 x 10 print; a 2-1/4 square negative requires a three and one-half times enlargement, and a 35 mm. negative is enlarged over eight times -- equal to a 32" x 40" enlargement from the 4 x 5.......

It is therefore obvious that small negatives can stand far less camera movement or careless composition requiring cropping than larger formats if sharp prints are to result. The sophisticated engineering, computer designing, rare earth glasses, meticulous assembly and resulting high cost of the finest lens is wasted unless the camera is still at the time of exposure. Long lenses magnify camera shake. Reflex mirrors jar the camera just prior to exposure and should be flipped up a few seconds early if conditions permit. Cable releases are better than releasing by hand or by self-timer mechanisms.

Edward Weston purchased an old lens of indeterminate make while he was in Mexico. He paid five dollars and, according to his daybook, his friends advised him that he had overpaid. Nevertheless, the images were sharp because the careful compositions utilized the full 8 x 10 negatives, the prints were made by contact, and the camera was always on a tripod.

My students hate to bring tripods on a field trip. They all have flimsy toys with fly rod legs; every connection sloppy; precise camera leveling impossible; inadequate height, and inconvenient controls. Just to screw on the camera is an odious chore. They end up using my tripod and are invariably pleased by far sharper, better composed full frame negatives. It doesn't take long to enjoy using a good tripod.

Very light tripods are generally recommended for 35 mm cameras, but the camera, also being light, does little to stabilize the rig. I use a tripod capable of handling an 8 x 10 for 35 mm. Even that tripod, weighing about 12 pounds, is solider with a view camera on it than with a lighter camera.

Many would argue that a tripod defeats the whole purpose of hand cameras in that speed and spontaneity suffer. I agree -- for those grab shots where speed is essential and composition and print quality are necessarily of secondary importance. A look though many photographers' contact sheets reveals that photographs requiring a hand held camera are less numerous than might be expected.

PUBLICATIONS

Aperture: Perhaps the most beautifully printed display of fine photography available at a reasonable price. The monographs of the works of Weston, Caponigro, Eugene Smith, etc. are collectors' items. They also publish fine books. Minor White is the editor, Michael Hoffman the managing editor-publisher, and Ansel Adams and Shirley Burden are directors.

Michael Hoffman
Aperture, Inc.
Millerton, New York

and please mention Zone VI.

Camera 35: Excellent articles on technique and equipment. Varied portfolios such as Larry Clark's "Tulsa" and Wynn Bullock in one issue. Writers include Howard Harrison, Paul Farber, Michael Edelson, David Vestal and the technical editor is Bob Nadler. Write to:

Camera 35
P.O. Box 562
Des Moines, Iowa 50302

Modern Photography: A big magazine well named. Articles on technique lean toward 35 mm format although Arthur Kramer writes a fine column on view camera technique. Color, lens and equipment test monthly. Writers are Arthur Kramer on large format, Herbert Keppler on small, Ed Scully on color and Wolfman on printing. Julia Scully handles the portfolios. They also list and review exhibits. Write to:

Modern Photography
P.O. Box 14117
Cincinnati, Ohio 45214

Popular Photography: Big, very professional and current. Balance of technical and equipment research with portfolios. Annual equipment directory and Annual; critique by Hattersley, interviews of photographers such as Eugene Smith by David Vestal, technique by Norman Rothschild, Harvey Zucker, Al Francekevich, Edward Meyers, and many more. Write to:

Popular Photography
Portland Place
Boulder, Colorado 80302

International Photo Technique: Superb color reproduction from Munich, but published in an English version. Sophisticated, large format, professional advertising orientation. Discussions of advanced equipment and techniques. Very authoritative. Write to:

Verlag Grossbild - Technik
8 Munich 25
Rupert-Mayer-Strass 45
West Germany

WORKSHOPS

Apeiron: Various fine instructors, year round schedule, individual darkrooms and workshops of a week to three months. Write Peter Schlesinger, Apeiron, Millerton, New York.

Yosemite Workshop: In June for about two weeks. Darkroom facilities; mountain photography with the master. Individualized, serious, but informal. Top instructors. Write Ansel Adams, Route 1, Box 181, Carmel, California about this and other workshops he holds during the year.

Zone VI Studios: Weekly evening meetings in White Plains; assignments, field trips, darkroom. Classes limited to 12. Portfolio submission required. Write to: Fred Picker, Zone VI Studios, 147 Hillair Circle, White Plains, New York 10605.

SERVICES

Good repairmen are hard to find. I can recommend with confidence:

> Foto Care Ltd.
> 134 Fifth Avenue
> New York, New York 10011
> Mr. Norbert Klieber

> Professional Camera Repair
> 37 West 47th Street
> New York, New York 10036
> Mr. Martin Forscher

Marty Forscher was kind enough to recommend:

> Adolph Gasser
> 5733 Geary Blvd.
> San Francisco, California

Color processing and printing. I use:

> Robert Crandall Associates
> 306 East 45th Street
> New York, New York 10017

The best I know of. Mainly for professionals who can understand the prices and appreciate the quality. Typical - first 8 x 10 print costs $20.00. Good color work is so rare that I would not suggest any other lab.

Densitometer check for proper A.S.A. speeds. Send the Zone 1 negatives taken at the various film speeds - see "film speeds." We will identify and return the properly exposed negative.

Densitomer check DE–1 – $5.00

<u>Thermometer check</u> against process thermometer — accurate to 1/4°. Faulty thermometers are the cause of many negative problems. We will compare your thermometer to actual 68° and return it with information regarding deviation, if any. Pack carefully.

Thermometer check TH–1

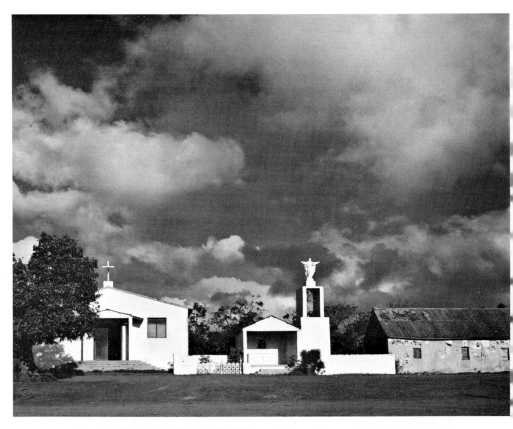

Church of Hangaroa, Easter Island: News photographers say the secret of good photographs is "F/8, and be there." This church is the center of island life and after three weeks I had been able to get nothing better than a "record" photograph. "Being there" finally occurred minutes before a violent rain squall and the photograph was made as the small black cloud passed behind the figure. The white church was placed on Zone VIII and a K-1 (light yellow) filter was used. 1/25 sec, f/22, tri X sheet film.

EQUIPMENT

In the United States, over four billion dollars was spent in 1971 for photographic equipment. If my past experience is typical, photographers wasted over one billion on shoddy construction or poor design. We eventually learn that good machinery can't be made for low cost and that high cost does not guarantee good performance.

Laboratory tests often prove unreliable because testers can't imagine or reproduce the combinations of circumstances that can occur in the field. As an example, a tripod bounces thirty miles in the trunk of a car, suffers a thousand miles of high frequency jet vibration at below zero temperatures, is well tested by the baggage attendants, and then must function under hot and humid conditions. The combinations are limitless and the equipment must handle them all repeatedly.

Useful analysis of equipment can only be made after continued use under actual working conditions.

The items listed have each passed that test. I believe they are either the best available or completely adequate to perform their function at nominal cost.

Several items not previously available have been manufactured to my designs. These have been field tested extensively and are unconditionally guaranteed to give complete satisfaction. Products of other manufacturers all carry the guarantee of the maker.

VIEWING FILTER

When I first attended the Yosemite Workshop, Ansel Adams distributed to each student a small brownish "gel"-like cellophane-filter. Looking through the filter was quite a revelation. It modified all of the colors, shadows and highlights in a scene to values very close to the values they would assume in a black and white photograph. It graphically showed shadows and colors as compositional forms.

It is very difficult to judge whether a merger of horizon, flesh tone, structure, etc. will occur against the sky

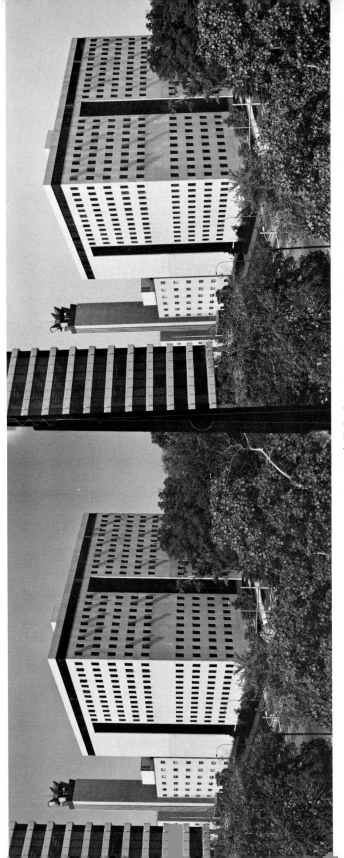

New York Telephone Co. Courtesy of the architects; Rose, Beaton and Rose.

The viewing filter showed too close a relationship between the sky and the sunlit side of the structure. The scene appeared through the filter as shown in the right hand print. The print on the left was made from a negative exposed through a "G" (light orange) filter. Negatives contact printed together – proper proof.

Photographing a building straight into a corner is generally poor procedure, but in this case there was little choice. To clear the tall trees, a rooftop position was necessary. The picture was made from the only roof position available that did not obscure the tower.

or other backgrounds. A glance through the filter gives information on what, if any, filtration is needed to avoid mergers. Green and blue are especially difficult to judge. The eye is extremely sensitive to green, but the film has less sensitivity to green than to any other color. Film has oversensitivity to blue and often skies print much lighter than they appear. Red prints lighter than it appears. This filter tells you in advance what to expect and even how to change it. (See illustration). If the sky looks too light through the viewing filter, use a green, yellow, or orange filter over the lens to darken it. That filter will also lighten the green trees.

A friend of mine who is a fine photographer returned from Greece recently and found that nearly all of his pictures were harsh and badly overfiltered. The skies printed almost black and the deep blue light in the shadows, reduced by filtration, printed without luminosity. The viewing filter would have shown the situation at a glance and he could have taken steps (no filter or weaker filter) to correct for the unfamiliar situation of extremely blue light.

Ansel gave each student another item. Deceptively simple in appearance, it provided everyone with instant compositional improvement. It was merely a black 8 x 10 card with a 4 x 5 hole cut into it.

Our two eyes enable us to see in depth. But the one eye camera "sees" only in elevation and the print also lacks the third dimension. By sighting through the card (with one eye) it becomes much simpler to organize the composition. Subjects in different planes appear more two dimensional as they will in the print. It becomes much simpler to relate near and far objects and arrange them to best advantage. The edges of the card frame vertical or horizontal compositions without distraction of subject matter outside of the desired area.

There is an auxilliary benefit in that you can hold the card 4" away from your eye and see just what area a 4" lens would include; 8" away gives you the scene an 8" lens would "see", etc. The 4 x 5 cutout used as a rangefinder would, of course, work only with a 4 x 5 camera, but I found it so helpful that I made 35 mm. and 2 1/4 square cards.

WESTON MASTER 6

The Master 6 has been designed to replace the Weston V. Differences include a more readable dial calibrated in candles per square foot. The meter is of the dependable selenium cell type as is the V. The range is from .125 to 2,000 candles per sq. ft. With case, neck ribbon and zone dial.

WESTON MASTER 6 METER

W-6

SEI EXPOSURE PHOTOMETER

"It functions under very low values of illumination — far beyond the capacity of the standard photoelectric meter (excepting electronic meters such as the Photovolt meters Nos. 500 and 501). Perhaps the chief value of the S.E.I. meter is its ability to solve hitherto impossible problems of exposure under complex lighting — small, dark objects against bright backgrounds, and vice versa; twilight scenes including street lights; very dark areas of architectural interiors; brilliant clouds near the sun, etc. It is extremely helpful in color photography, where a critical evaluation of highlight and shadow values is of decisive importance."

Reprinted from "The Negative" by Ansel Adams, Morgan & Morgan, Inc., Publishers.

1. The range is 1 to 1,000,000
2. ½° can read flesh tone at 70 feet or meter the moon.
3. Self standardizing regardless of temperature, brightness of object viewed, or color of object.

The last, I think, is the most important attribute of this marvelous instrument. You make a reading by lining up a meter needle with a standard mark. This zeroes the meter. Sighting through it, you see a ½° lighted spot superimposed on the scene. Rotating the base lightens or darkens the spot until it "disappears" into the tone of the object. Readings are then made from the scales.

This is the only meter I know of that is perfectly linear throughout its range. It "reads itself". The comparison spot which is zeroed each time it is used. It is therefore unaffected by the factors that less sophisticated meters must deal with.

The reason that we have not listed this meter before is that it was extremely difficult to use in the field. Since it is set up to meter a Zone II. If you read a value you wanted to place on Zone VII, the mathematics required were frightening. This problem, after two years of frustration, has been solved and we supply a Zone Dial and instructions that make it as easy to use as a Weston 6.

More technical information is available by request.

SEI.......

WESTON MASTER 6

The Master 6 has been designed to replace the Weston V. Differences include a more readable dial calibrated in candles per square foot. The meter is of the dependable selenium cell type as is the V. The range is from .125 to 2,000 candles per sq. ft. With case, neck ribbon and zone dial.

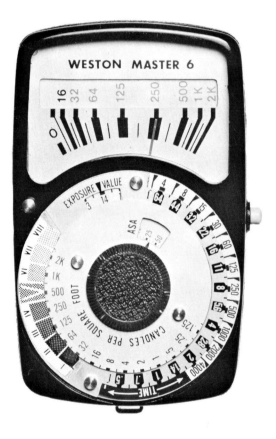

WESTON MASTER 6 METER

W-6

or other backgrounds. A glance through the filter gives information on what, if any, filtration is needed to avoid mergers. Green and blue are especially difficult to judge. The eye is extremely sensitive to green, but the film has less sensitivity to green than to any other color. Film has oversensitivity to blue and often skies print much lighter than they appear. Red prints lighter than it appears. This filter tells you in advance what to expect and even how to change it. (See illustration). If the sky looks too light through the viewing filter, use a green, yellow, or orange filter over the lens to darken it. That filter will also lighten the green trees.

A friend of mine who is a fine photographer returned from Greece recently and found that nearly all of his pictures were harsh and badly overfiltered. The skies printed almost black and the deep blue light in the shadows, reduced by filtration, printed without luminosity. The viewing filter would have shown the situation at a glance and he could have taken steps (no filter or weaker filter) to correct for the unfamiliar situation of extremely blue light.

Ansel gave each student another item. Deceptively simple in appearance, it provided everyone with instant compositional improvement. It was merely a black 8 x 10 card with a 4 x 5 hole cut into it.

Our two eyes enable us to see in depth. But the one eye camera "sees" only in elevation and the print also lacks the third dimension. By sighting through the card (with one eye) it becomes much simpler to organize the composition. Subjects in different planes appear more two dimensional as they will in the print. It becomes much simpler to relate near and far objects and arrange them to best advantage. The edges of the card frame vertical or horizontal compositions without distraction of subject matter outside of the desired area.

There is an auxilliary benefit in that you can hold the card 4" away from your eye and see just what area a 4" lens would include; 8" away gives you the scene an 8" lens would "see", etc. The 4 x 5 cutout used as a rangefinder would, of course, work only with a 4 x 5 camera, but I found it so helpful that I made 35 mm. and 2 1/4 square cards.

Students liked the improved composition and tones achieved but they didn't like to carry the 8 x 10 cards and delicate gels.

Zone VI Studio now manufacturers a viewing filter that is available in 3 different formats for color or black and white. The area surrounding the filter is black. The fragile filters are sealed in plastic and will last indefinitely.

The viewing area of the 35 mm viewing filter is the size and shape of the negative so if you hold it 4 inches from your eye, you will see the area a 100 mm (4") lens will cover etc. The 2-1/4 square and 2-1/4 x 2-3/4, 4 x 5, 8 x 10 (last three are the same format shape) have been reduced to 3" x 3" overall so that they can be conveniently carried on the neck cord. You will soon learn to adjust the filter-eye distance to conform to the coverage of various lenses; a black and white filter will be sent unless you specify <u>color.</u>

The color filter is of different material. It indicates the higher contrast that will result from the shorter range color film.

VIEWING FILTER VF-35

Viewing Filter	for	35 mm, 5x7	VF-35
" "	for	120 mm	VF-2x2
" "	for	4 x 5 (etc.)	VF-45

82

WESTON RANGER 9 MODIFICATION

This meter has the most sensitivity and the most readable dial of any I know of. The angle of view is narrow -- 18° compared to 38° for the Weston V and 6. The sensitivity range is 1 to 1,000,000. It has a sighting aperture so that you can see what the meter is reading.

The basic excellence of this meter has been utilized to give even finer performance. We have shielded the cell area from extraneous light (flare) which could affect the readings, especially in back-light situations. In addition, the angle of view has been reduced to about 4°. This modification causes the loss of two stops (inconsequential in light of the inherent sensitivity), so the ASA dial must be set to four times the actual speed desired. If your speed test with another meter resulted in 300 ASA for Tri-X, set this meter for 1200 ASA, then read the same surface with both meters. Now re-adjust the ASA speed of the Weston if necessary so that the exposure information matches that of the other meter (f/11 at 1/125, etc.) Write a label -- "TX-1200" and attach it to the meter. This procedure should be followed with any new meter.

To get full benefit from the 4° modification, it was necessary to improve the sighting characteristics to show the exact area being metered. The original sight was a peephole with a marked circle inside to show the area being covered. It was a bit like a gun with only a rear sight. We have added a front sight so that you can aim it precisely. Holding the meter about 12" from your eye shows the area being covered and the movement of the needle. The range of the modified meter is 1 - 250,000.

Modification includes Zone Scale.

Your Ranger 9 meter modified as
described (pack carefully)

SOLIGOR 1° SPOT METER

This meter has a field of view of 15 degrees, but the actual metered area is only one degree as indicated by a circle in the viewfinder.

You can easily meter the highlight on a cheekbone at 8 feet or the top floor window of a building. The low light sensitivity is not as great as the Ranger 9 because of the very narrow angle, but it will give a reading for a Zone V exposure as low as 1/4 second at f/2 when set at ASA 200. Prior to using the Soligor, I had two 1° meters of another brand. I bought the second one because I thought that the first was just unlucky for me. It spent a lot of time in the shop. So did the second one. My repairman (reluctantly, I think) suggested the Soligor, and it does everything exactly the same as the first two except break. It also has a die cast body instead of fiber glass, is smaller, has twice the range (1 - 64,000), and costs about $30.00 less. The lens is 100 mm. f.2.8., coated, and the viewfinder is an adjustable diopter with a pentaprism. One of the nicest features is that releasing the trigger turns off the meter, so you don't have to carry around the very loseable lens cap. ASA settings from 6 to 12,800 and lens openings from f/1 to f/128.

Shipped with Zone dial, lined leather case, wrist strap, lens cap and batteries.

SOLIGOR 1° SPOT METER

Sol – 1

ZONE DIALS

Our Zone Dials have permanent self-adhesive backs. They are precision die cut and the shades of gray correspond to the print values quite well. In addition, the Zones are numbered — black on white to avoid confusion and for readability in low light. Peel off the sheet backing and apply to your meter dial making sure that Zone V covers the arrow.

If you are purchasing a meter from Zone VI, do not order a dial, since dials are included with purchase of meter.

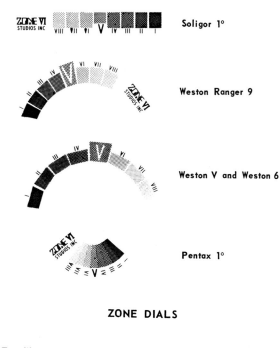

Soligor 1°

Weston Ranger 9

Weston V and Weston 6

Pentax 1°

ZONE DIALS

For Weston V	ZD-W5
For Weston 6	ZD-W6
For Weston Ranger 9	ZD-9
For Soligor 1°	ZD-SOL
For Pentax 1°	ZD-PE

FOCUSING CLOTH

The commercially available little black transparent cloths are worthless. The Zone VI focusing cloth is two-ply, opaque, oversized, washable and weighted all around. The black side is of material that won't slide off your head. The white side is reflective to keep you cool. If your camera is standing in the sun, put the cloth over it, white side out, and put other equipment and film between the tripod legs.

You can use it for a reflector or a black or white portrait background. The weights at the edges keep it from flapping in the breeze.

FOCUSING CLOTH FC..................

ZONE VI TRIPOD

I have used the Majestic tripod for years and found it to be rugged, dependable, fast and convenient. The latest model is even better than my old one.

It is known as the S-106 and is of clear anodized aluminum tubing and light alloy castings with a tough black baked enamel finish. There is a three way built-in level for adjusting each leg quickly, moveable rings with which to preset leg spread angles, tension springs on all hand wheels to keep them from getting lost, and tension bushings line each moving clamp for smooth movement and positive locking. Quick and positive raising of the centerpost (to 6' 6" height) is accomplished with a foldaway crank operating a spring loaded ratchet. Even if you let go of the crank, the camera stays up safely. Each leg is braced by strong double brackets. The tripod weighs 10 lbs. without the head and extends from 34" minimum height (floor level with optional sidearm) to 80" including raised centerpost. A height of 64" to the camera base is achieved by leg extension alone. The solidest setup for any tripod occurs when the full length of legs is utilized rather than a long extension of centerpost.

The Zone VI tripod is expensive, but it is the very best and you'll never have to buy another tripod.

MODEL S-106

Tripod , head mounted	TR-1
Sidearm for floor level to 34 inch elevation	TRS-1
Quick detachable spike feet — cover the somewhat bouncy rubber buttons. Better anywhere (except fine floors).	SF-1

HUSKY TRIPOD

The quick set Husky model 3-D. Toughest, solidest tripod in its class. Three section legs, geared centerpost, fine panning head with big camera screw and separate controls for horizontal (to vertical) and side tilts (to 90°).

Weighs 7-1/2 lbs. and measures 30" closed, 72" open. Best for 35 mm and 120, and good for 4 x 5 on windless days.

HUSKY TRIPOD 3D...................................$70.00 *includes shipping*

Husky Hi Boy 3D - same as above but with four section legs. Extends to 90" height, weighs 8-1/2 lbs.

3D HI

ZONE VI STUDIOS COLD LIGHT HEAD

The advantages of cold light illumination for enlargement were indicated in an earlier section of the text.

The Director of Photography of Rye Country Day School, Rye, New York, Mr. Wesley Disney, writes of his experience;

"I was familiar with the theory of dispersion of collimated light in the denser areas of the negative as embodied in the Callier theory but had always discounted the magnitude of the effect. I find that this was a serious mistake. I can't imagine how many photographers are being frustrated by the printing characteristics of their condenser enlargers. Regarding the 8 x 10 prints enclosed, all were exposed for black film edge. (9 seconds f/11 with cold light). The contact reproduces the previsualized image perfectly and the cold light enlargement (unmanipulated) is identical to the contact print. The unmanipulated condenser enlargement shows an absolutely blank sky! To get a result from the condenser approaching the quality of the straight print from the cold light required exposure times for different parts of the print ranging from three to thirty-five seconds..........."

Cold Light Heads are available for almost any enlarger from 2-1/4 to 8 x 10. Each model is thermostatically controlled to provide instant start full intensity output when a timer is activated. The installation is accomplished by removing the condensers and lowering the cold light unit into their place.

Units are oversize for complete negative coverage. Typical is the D-2 model for Beseler and Omega 4 x 5 enlargers. It is 6-1/2" in diameter, 4-5/8" high and weighs 4-1/2 pounds.

The units consist of spun housings containing small diameter glass tubes tightly folded back and forth to evenly cover the entire diameter of the housing. These tubes are filled with special phosphers which will provide no less than 10,000 burning hours (constant illumination night and day for a year and three months!). A single sheet of opal diffusion blends the lines of the grid lamp into a perfectly even sheet of cool actinic light. Negatives never buckle. There are no condensers, bulbs, or lamp housings to clean. An occasional wipe of the diffusion sheet is the only attention the unit requires. Printing speeds are about the same as with most condenser enlargers.

The units are equipped with either "daylight" or "warm white" lamps. The lamps are interchangeable in the event you decide to change papers in the future. Cost of a new lamp is about $20.00.

The daylight lamps (W-45) are highly actinic (bluish light) and are best for all graded papers if high speed printing is desired. They would produce a grade 4 result if used without a filter for variable contrast paper. They can be modified for variable contrast paper if a CC40Y Kodak gel filter is taped to the negative carrier. DuPont or Polycontrast filters are then employed to change the contrast.

The warm white light source (W 31) should be ordered if your normal paper is variable contrast. These units print a #2 grade on Varigam, etc. without a filter. Polycontrast or DuPont filters are then added to change contrast grades.

The W 31 light source will also print graded papers perfectly, but with less speed than the daylight (W 45) unit since graded papers are insensitive to part of the color spectrum produced by the warm white source. Prices are the same for W 31 and W 45. Please specify your choice. If you don't see your enlarger listed, write us. We can even fit a wooden Elwood!

Installation of these units is simple. Remove condenser and replace with cold light. The heavy cord marked "Thermo" is plugged into a wall outlet: the thinner cord is plugged into the timer. Allow two minutes for warm up and remove the heavy cord from the outlet after the printing session.

For commercial applications or mural sized prints at high speeds, extremely high intensity lamps can be made. Send your requirements for price quotation.

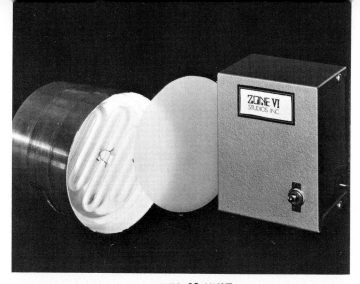

BES 23 UNIT

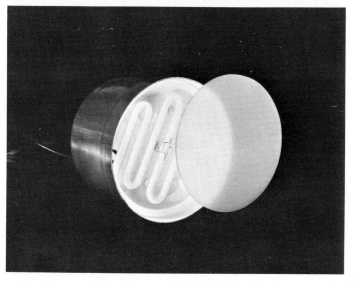

D-2 UNIT

For	Model
Omega D-2, D-3, Beseler 4 x 5* Printex, Sunray 4 x 5, etc.	D-2
Solar 57 and 45. Elwood 10", 12" and 16".	57
Omega B22	B22
Omega B4, B5, B6, B7, B8, DeJur 1 and 2, Federal 311, 312, 315, Solar 120, 66	23
Beseler 23C	Bes 23
8 x 10 Salzman, Folmer, E.K. Autofocus 8 x 10, Elwood 8 x 10	1212
View Cameras 8 x 10 (slight adaptation often necessary)	810
5 x 7 Salzman	88
*Requires special collar	B-col.

93

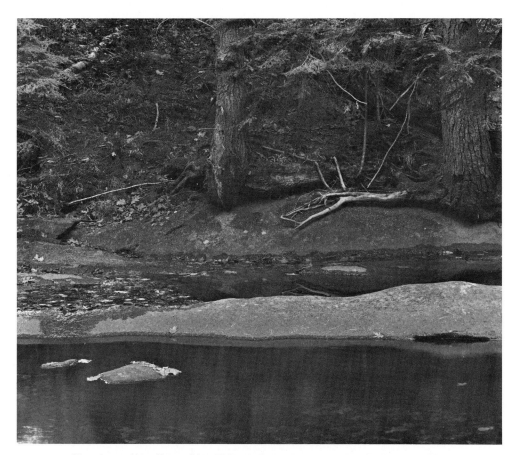

Near Lynn, New Hampshire: This photograph was made after sunset. The light quality was soft and rich. The negative prints without manipulation on #2 paper and the lowest print values are the shadows under the tree boles (Zone I); the highest value is in the fallen branch (Zone VII). Higher contrast paper destroys the quiet mood and the gentle quality of light. A full scale print (showing pure black and pure white) would not be appropriate in this case.

CODELITE - VARIABLE CONTRAST
COLD LIGHT HEAD

For all 4 x 5 enlargers. Described as to function in the body of the text.

Installation of the Codelite on your enlarger is fast and easy. No special adapters are needed. All you do is loosen the set screws on your present light head, take off the head, put the Codelite in its place and tighten the set screws again. The Codelite head is permanently connected by cable to the console. Two labeled leads extend from the console -- the one labeled "120" goes to a standard wall plug; the other labeled "Timer" is plugged into your timer. Your timer's cable is plugged into a power source outlet marked "Timer" located on the left side of the control console.

The "power on" switch operates the console and the amber indicator lights above each dial.

Each printing light is controlled by a separate on/off switch -- soft light, hard light and second hard light. Your timer controls focusing and exposures.

Codelite features:

1. Separate rheostats mix soft and hard lights for infinitely variable contrast grades between 0 to 4. Nine grades are marked.

2. Dialing a higher or lower contrast requires no adjustment of F stop or time. The density remains constant -- only the contrast changes.

3. The light is cold; negatives never buckle.

4. The thermostats keep the unit ready to start up at full intensity.

5. Can be operated from any timer.

6. Fast printing when desired. My average time for 4 x 5 negatives and Varigam is 11 seconds at f/11 for 11 x 14 prints. For faster or slower printing, both rheostats are adjusted to a higher or lower number. Lights stay in balance and contrast remains constant.

7. Easier to focus and sharper prints because of the absence of filters. No filters to change, clean or deteriorate.

8. The two hard lights at full intensity are designed for making black and white prints from color negatives or very fast printing on graded papers.

9. Easy to clean -- wipe off diffusion plate. Everything else is sealed.

10. Models for almost all 4 x 5 enlargers. (Specify brand and model)

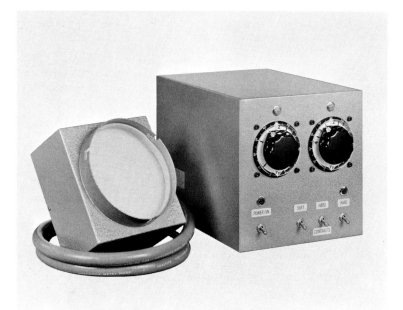

CODELITE HEAD FOR BESELER 4 x 5

CODELITE — CO-1............................$658.20 *includes shipping*

FINE PRINTS

Fine Prints for comparison or display. During printing sessions, comparing results with prints containing known values is of great help. The difficulty is not in achieving the proper tonal value or contrast, but deciding what those values should be.

I will make a full scale 8 x 10 print, toned, archivally processed, and trimmed. A detailed description of placement, exposure, filtration, equipment, materials and printing technique accompanies each print. Prints are in clear plastic envelopes for protection in darkroom. Please specify architectural (see illustration - Barns Near Paterson, New York), natural scene (see - Beach Near Lunenberg, Nova Scotia), or portrait.

Architectural Print	FPA
Natural Scene Print	FPS
Portrait Print	FPP
All Three Prints	FP3

RAPA NUI — EASTER ISLAND BY FRED PICKER: Text and 80 photographs plus a superb historical perspective by the famous archeologist Thor Heyerdahl, author of "Kon Tiki", "Aku, Aku" etc. 300 line screen half tone reproductions by Scroll Press accurately reflect the mysterious quality of an incredible land. Separate supplement, "About the Photographs," explains techniques and materials employed, 144 pages, hardbound, signed by the author.

LABORATORY SINK

This is a lightweight polystyrene sink measuring 60″ x 24″ x 6″ high. It will hold up to 3 16″ x 20″ trays and can be easily stored upright after use. The drain at the end can be arranged over a kitchen sink or laundry tray or a standard garden hose can be fitted to carry drain water to a remote location.

Sink support requires only a simple table, counter, or 2 x 4 frame. Nail together a rectangle of 2 x 4's same size as the sink. Nail a 2 x 4 leg into each corner. (Suggested height to top of sink rim is 2″' below your elbow height.) 2 x 4's running all around can be nailed to the legs about midheight. A plywood shelf can be laid on these for storage of trays, chemicals, etc. Camera and Lens-Book One by Ansel Adams has a fine darkroom layout, counter designs, lighting and plumbing suggestions, etc.

DRS-1

TEMPERATURE CONTROL UNIT

Temperature Control Unit regulates water temperature to 1/2° regardless of change in line pressure or temperature. These units usually sell for about $200 but without sacrifice of any of the control mechanisms we are able to achieve identical results for $117.50 per unit. The savings involves loss only of the built-in thermometer section and once you regulate the temperature, you don't need the thermometer. Just run water through the unit into a graduate containing your thermometer and adjust the temperature control handle until you achieve 68°. There is a separate on/off and volume control so it is unnecessary to reset the temperature control each time.

Complete with 2 union angle stop and check valves (with strainers) for pressure balance, thermostatic mixer body, and temperature and volume controls. 1 - 4 gallons per minute capacity. Accepts normal 1/2" threaded pipe.

Installation of temperature control unit in Zone VI darkroom: TC-CT unit shown. TC-B and TC-C units do not include the thermometer section. ½" lines screw into the stop and check valves, temperature is adjusted by the circular valve and tempered water flows through the thermometer section. It is then divided to feed a garden hose valve outlet used for washing film, mixing solutions, etc. The other line goes through a timer and then to the print washer.

Five gallon chemical storage tanks are 16" high, so the water outlets are 21" above the sink bottom.

		Same, but with thermometer	
Brass	TC- B	Brass TC- BT...........	
Chrome	TC- C	Chrome TC- CT	

FATIGUE MAT

A real luxury in the darkroom. 27'' x 60'', chemical proof black ribbed top surface bonded to a 1/2'' spongy core. All edges are sealed. A must if you work on concrete, and very comfortable on any floor.

Fatigue Mat — MA2760................

SALON CASE

Strong fibre carrying and shipping cases for prints. Steel corner protectors, webbing straps with buckles and carrying handle. The 1-1/4 inch case carries 15 mounted prints, the 4 inch case carries 48 mounted prints.

Salon Case — 16 x 20 x 1¼ SC-1...............
Salon Case — 16 x 20 x 4 SC-4...............

MODEL RELEASE FORMS

Many outstanding photographs are financially useless simply because there is no model release. I keep forms in each camera case. I find it is no problem to get them signed at the time the photograph is made if I offer to send the subject a print.

100 Model Release Forms MR100....................

GRAIN MAGNIFIER

Provides over 200 times magnification of a 35 mm. image projected to 8 x 10 size.

Adjust the eyepiece position for your vision until the etched ring seen on the ground glass is perfectly sharp.

Place the magnifier on the easel under the projected image and focus the enlarger until the grain is sharp with the enlarger lens wide open. A scrap print under the magnifier raises it to the correct height. If the grain is sharp, the print will be as sharp as the negative and projection equipment will allow.

Grain Magnifier — MAG. 200....................

TIMERS

Gralab model 300. Electric timer with 8 inch luminous dial times one second to 60 minutes. Buzzer signal can be switched on to signal end of wash, etc. Best for timing film and print development. All steel with chemical proof polyurethane finish. Focus/time switch allows control of enlarger and safelights through separate receptacles.

Gralab Timer — GR-300.......................

ELT Timer — When I was assisting Paul Caponigro with his Portfolio II, it quickly became apparent that the old spring wound "standard" timer was unable to deliver the repeatability required to produce 100 matched prints. This timer was purchased and it operated flawlessly through over 1,000 exposures. I since purchased one for myself and find it a vast improvement over my old mechanical timer. 1. It can be set from .2 to 60 seconds in .2 second increments. 2. It is all solid state — no springs, no motor, no annoying buzz or hum, no vibration. 3. Its repeatability error is less than 1/5 second regardless of the time setting. 4. It has a unique circuitry that lengthens or shortens the exposure in response to line voltage fluctuations. 5. Resets automatically unless you change dials. Switch for focus. 6. Voltage: 115 AC, 50-60 cycles, Capacity 1000 watts A.C. Size, 6 x 8½ x 3½, fittings for optional complete wall mount. 7. Delivered with foot switch.

Double action Foot Switch

ELT. 1 ...

WASHER - STAINLESS STEEL

For films and prints. Best way to wash sheet film and also useful for about ten 11 x 14 or 8 x 10 prints. Twenty-one water jets at three levels inject water at one end of the tray and water flows from corresponding holes at the opposite end. Ribbed bottom assures circulation of water under film or prints. Films meander about without damage and require no hand agitation if you tip up the outlet end of the tray about one inch. Prints should be rotated and inverted occasionally.. The hose connection supplied pops off the water faucet, so we include a screw type connection and Ht-2 test solution in dropper bottle.

13" x 17" x 2" — hose supplied

Stainless Washer STW.........................

ROTARY PRINT WASHER

Constant agitation by water drive. No electric motor problems. Exchange rate adjustable for one to two gallons per minute. No print damage in my long experience with this unit. Stainless perforated drum revolves on bronze bearings and continuously rearranges the prints. Ten gallon tank with hose to standard faucet, connector, bottom drain, and overflow hose included. Will handle prints to 11 x 14. Stated capacity 75 - 8 x 10 single weight prints. 25 - 8 x 10 double weight prints achieve archival standard in under one hour in my washer. This washer has been in almost daily use in my darkroom for five years.

Detail shows washer with drum open for loading. Incoming water rotates drum by pressure against turbine blades.

Rotary Print Washer

We also include Ht-2 test solution in dropper bottle so that you can determine best washing times with varying water chemistry, gallonage, size, weight, and number of prints. See "Print Washing" for description of test procedure. Overall size 21-1/4" x 15" x 13".

Rotary Print Washer RO-1

HT-2 TEST SOLUTION

Contains solution for over fifty tests. Plastic dropper bottle.

HT-2 Test Solution HT-2.............

PROOFER

Simple, well constructed, uses 8 x 10 paper to proof 36-35 mm, 12 - 2-1/4 square or 4 - 4x5 negatives. Hinged pressure plate is of optical quality glass.

Proofer **PP**

SAFELIGHTS

Safe Safelight — At a very reasonable price. 5 x 7 filter is so effective that there is no trace of fog after a two minute exposure of pre-exposed Varigam. Test was made with the paper 4 feet from the light and a 25 Watt bulb was used instead of the recommended 15 Watt bulb. A recently tested $125.00 light could not match this performance. (A light that is safe with Varigam is safe with any paper.)

The light can be wall mounted or stood on a counter. Shipped with filter referred to, on - off switch, six foot cord. Available in 10 x 12 size as well as 5 x 7.

SAF 5 x 7 ...

SAF 10 x 12 (uses 25 Watt bulb) ..

WATER FILTERS - FILTERITE

Seamless brass mono-shell inner construction with leakproof "O" ring seal and one 10 inch filter. Stainless steel outer shell is directly installed on threaded 3/4 inch water lines or 1/2 inch lines with step-up adapter. Will handle pressure up to 150 lbs., temperature up to 150°, and volume up to ten gallons per minute.

My filters last about six months on the cold line and about eighteen months on the hot line.

Installation of Filterite water filters in Zone VI darkroom. One inch lines are reduced with standard reducers to ¾". After filtration, water goes to the temperature controlled outlet.

Height 14-3/8", weight 6¼ lbs.

Water Filter — with one filter	LMO
Additional filters	F-1
Wall mounting bracket	FWB

DEVELOPING TANKS

Stainless steel daylight tanks are guaranteed for the life of the purchaser. They are easy to clean, completely lightproof and fill and empty quickly. The professionals standard. Reels are heavy stainless spot welded and free of burrs or imperfections.

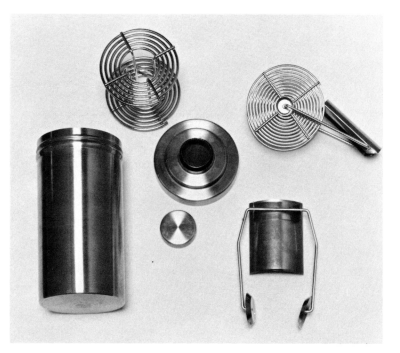

8 oz. tank only (no reels) for one roll
(20 or 36 exposures) 35mm T-8

15 oz. tank only (no reels) for one roll
120 or two — 35mm T-15...............

30 oz. tank only (no reels) for two rolls
120 or four — 35mm T-30...............

60 oz. tank only (no reels) for four rolls
120 or eight — 35mm T-60...............

Reels — 35mm — 20 or 36 exposures R-35...............
 120 R-120.............

Snap-on film loader—stainless for 35mm FL-35............
Snap-on film loader—stainless for 120 FL-120..........

PAPER SAFES

Safe, convenient storage for paper. One hand opens and removes a sheet and the boxes close automatically. Stores 150 sheets of double weight paper.

Paper Safe (8½ x 11 x 2)	**811 P.S.**
Paper Safe (12 x 16 x 2)	**1216 P.S.**
Paper Safe (16 x 20 x 2)	**1620 P.S.**
Paper Safe (20 x 24 x 2)	**2024 P.S.**

DRY MOUNT JIG

The drymounting jig referred to earlier in this book is a measuring and squaring device for the accurate and speedy mounting of prints.

To use, center the mountboard by slipping its lower edge under the chamfered base strip and move, for example, an 18 inch board left or right to line up with the 18 inch mark at both edges. Position the print by eye and when it looks right, slide the T square down over the mount to top or bottom of the print and center the print between same numbers.

A 12 inch print will go to the 12 inch mark on both edges and will be square across when in contact with the "T" square edge. Put the weight bag (included) on the print to hold everything in place and tack the print to the mount as described earlier. The solid wood base is cross laminated and edged in white formica and the fittings are heavy white plexiglas. Will handle prints or mount boards to 21 inches wide by any height. Shipped with weight bag and foxtail brush.

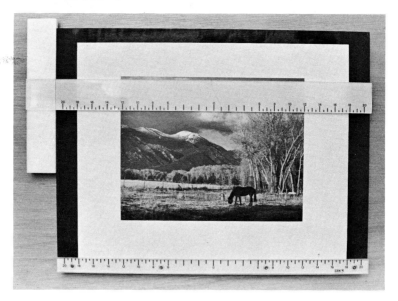

In actual use, the print edge is in contact with the "T" square edge

Dry Mount Jig — DMJ $38.00 incl. shipping

ZONE VI FILM EXPOSURE AND DEVELOPMENT CHART

FILM TYPE _____

SIZE _____

PERSONAL ASA _____

DEVELOPER _____

DEVELOPMENT TIME _____

PROPER PROOF

MAGNIFICATION _____
(Enlarger Head Position)

LENS _____

LENS STOP _____

EXPOSURE IN SECONDS _____

PAPER BRAND AND GRADE _____

PRINT DEVELOPER _____
AND TIME _____

PRINTING RECORD

Roll # _____ Film type and size _____ Date _____

Frame #	Magnification (print size)	f/stop	Exposure (seconds)	Paper (brand and contrast)	Notes

ZONE VI NEWSLETTER

A quarterly newsletter devoted to an exchange of ideas and information among photographers. Subscribers are invited to share successful applications of technique, submit questions regarding their problems, and air their thoughts in any area of general photographic interest.

There is a section where you may list equipment you would like to sell, and perhaps locate equipment that you would like to buy.

Each issue contains a section relating to application of technique or procedure to solve specific problems. Future issues will discuss filters, portraiture, darkroom design, and approaches to the natural scene. Each issue will be punched for insertion in this workbook for reference. Tested new products will be described. Several Zone VI products are currently being developed and if found worthwhile, additional catalogue pages will be sent to subscribers.

Advances in equipment and techniques are constant. Zone VI Newsletter will keep this book up to date by supplying subscribers with substitute pages when new developments indicate better procedures.

Another section will list exhibits, workshops, new books, porfolios and other items of general interest.

No advertising. The Zone VI Newsletter will not be a market place, but a meeting ground where photographers can exchange information of value.

Zone VI Newsletter NLper year $ 5.00
three years $10.00